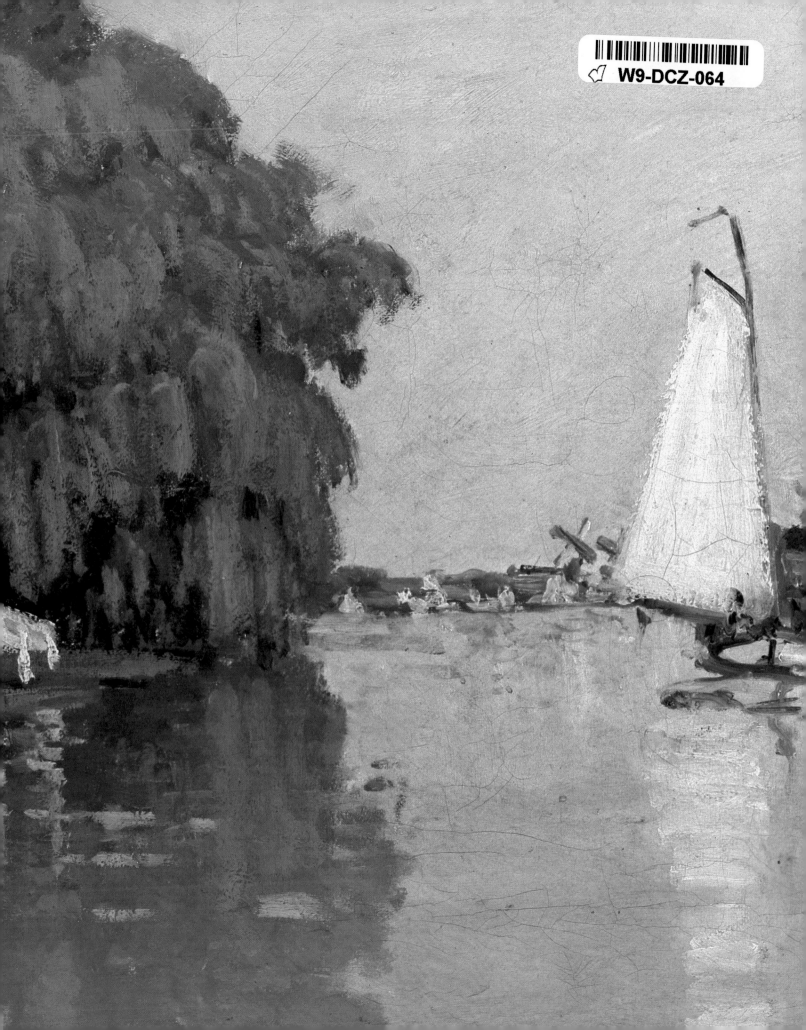

Mickenberg, David and Dr. George Szabo
*Impressionism/Post-Impressionism: XIX and XX Century
Paintings from the Robert Lehman Collection of the
Metropolitan Museum of Art.*

Library of Congress Catalogue Number 83-060136
ISBN 0-911919-00-7

IMPRESSIONISM
POST-IMPRESSIONISM

XIX & XX CENTURY PAINTINGS FROM THE ROBERT LEHMAN COLLECTION OF THE METROPOLITAN MUSEUM OF ART

CATALOGUE

Dr. George Szabo
Curator, The Robert Lehman Collection

IMPRESSIONISM

POST-IMPRESSIONISM

XIX & XX CENTURY PAINTINGS
FROM THE ROBERT LEHMAN COLLECTION
OF THE
METROPOLITAN MUSEUM OF ART

OKLAHOMA MUSEUM of ART
APRIL 23 · 1983 · JULY 18

*This catalogue partially funded by the
First National Bank & Trust Company of Oklahoma City.*

OKLAHOMA MUSEUM *of* ART

IMPRESSIONISM
POST-IMPRESSIONISM

XIX and XX Century Paintings from the
Robert Lehman Collection of the Metropolitan Museum of Art

Exhibition Sponsors

CONTENTS

David Mickenberg
Director

I T IS OFTEN difficult to explain that that which is now so uniformly accepted, appreciated and even loved was once indicative of a break with the past that resulted in almost total non-conformity. Such is the case of Impressionism, a movement whose universal acclaim today has diminished the recognition of its once radical nature. With hindsight we understand that Impressionism was the pivotal artistic movement of the 19th Century that allowed for the birth of Modernism. Yet the genteel beauty of nature seen in Monet, the fugitive moments painted by Seurat, and the celebration of youth and beauty portrayed by Renoir give little hint of the boldness that often left Impressionist artists disenfranchised, in poverty and opprobrium. To those who attended the official salons in Paris art was a learned process, and an historical one. It was not, as it was to the Impressionists, concerned with truth, perception, nature and the painting process itself.

John Rewald wrote that "...the struggle between Academic art and Impressionism which dominated the second half of the last century...was not a competition between equal forces. Those who...endeavored to stem the tide of Impressionism had nothing to offer but stillborn concepts,

antiquated ideals, empty shells, and a contemptible willingness to accommodate the conquests of "plein-air" painting to the debased taste of the salon jury." (John Rewald, *Pissarro*, 1980, p. 10) *Impressionism/Post-Impressionism: XIX and XX Century Paintings from the Robert Lehman Collection of the Metropolitan Museum of Art* is, therefore, not an exhibition presenting a survey of artistic currents in France during the 19th Century. It is, instead, a very deliberate grouping of paintings representing a time of change and innovation that forever altered the face and nature of art. Drawn from one of the most extensive holdings of Impressionist art in the United States, *Impressionism/Post-Impressionism* presents not only some of the key Impressionist paintings, but works representative of the influences upon, as well as the movements emanating from, Impressionism. It does, therefore, document a momentous period in the history of art.

The towering geniuses of Impressionism: Monet, Renoir, and Degas, and of Post-Impressionism: Cézanne, Signac, Derain, Gauguin, van Gogh, and Matisse, are well represented by important works in this exhibit. Due to the keen eye of Robert Lehman we are fortunate to be able

to allow our audience the experience of viewing key works by artists not as familiar to the public. Paintings by Albert Andre, Henri Cross, Paul Trouillebert, Louis Valtat, Suzanne Valadon, and rare Fauve works by Georges Braque and Maurice Vlaminck add a new dimension to our understanding of the diversity and excitement inherent in this period.

While being at once a "celebration and an exploration," *Impressionism/Post-Impressionism* is also a testimony to the taste, connoisseurship and foresight of Robert Lehman. Begun in 1911 by his father Phillip, while Robert was a student at Yale, the Lehman Collection is one of the last great American encyclopedic collections of art. While the first purchases in the collection were of works by Rembrandt, Goya, Hoppner and Cossa, the collection quickly began purchasing Italian Renaissance paintings, a direct influence of Robert's studies of the Jarves Collection at Yale. By the 1930's Flemish and Northern European paintings including the famous Petrus Christus and Memling's *Annunciation* had joined the greatly enlarged collection of Italian works including a Bellini *Madonna* and Botticelli's *Annunciation*. A large and magnificent collection of Italian majolica, medieval and renaissance bronzes, illuminated manuscripts, renaissance furniture, paintings and docorative arts were gradually added to the collection. There were two areas of the collection for which Robert Lehman alone was accountable from the start. The magnificent collection of old master drawings with a range from Pisanello to Modigliani is one such area. In keeping with the rest of the collection, the old master drawings are considered one of the finest groupings in the world.

The second and final addition to the collection were the 19th and 20th Century French paintings. The Impressionist, Fauve, and Pointillist works were collected before taste and history could confirm Mr. Lehman's choices. It is from this superb grouping that *Impressionism/Post-Impressionism* is drawn. Since the bequest of the Lehman Collection to the Metropolitan Museum of Art in 1975, most of these works have been seen on permanent view in the upper galleries of the Lehman wing. This is the first time that an exhibition outside of the Metropolitan, specifically of the 19th and 20th Century Lehman paintings, has been organized. This exhibition catalogue presents the first opportunity to publish many of the individual works in the collection as well as the first publication to be specifically concerned with this portion of Robert Lehman's superb gathering of art. In viewing and studying these works, one can only agree with the Parisian art critic who observed on the occasion of the collection's exhibition at the Orangerie in 1957, "We would like the purchases of our museums to be inspired by a taste as severe as that of which Robert Lehman today gives us dazzling evidence."

Impressionism/Post-Impressionism really germinated in 1981 during the final days of our prior exhibition, *Maurice Prendergast's Large Boston Public Garden Sketchbook*, from the Lehman Collection. Now, as it was then, it has been an immense pleasure to work with Dr. George Szabo, Curator of the Lehman Collection. His willingness to share the wonders of the collection, to write the exhibition catalogue, and to give his time, energy and scholarship to this project, as well as his patience and assistance in finalizing the myriad of details that are involved in such a large exhibition have been an example of museum

professionalism and friendship at its best.

I would like to thank the Trustees of the Lehman Foundation and of the Metropolitan Museum of Art for their generosity in loaning the collection, their trust, and belief in the fact that art is not just for the few but is to be shared by the many. To the staff of the Lehman Collection I have only good feelings. Their assistance and kindness in helping prepare the catalogue and in making arrangements for the exhibition has made this project a very pleasurable undertaking. Special thanks also goes to Herb Moskowitz, Registrar at the Metropolitan Museum of Art for his tireless efforts in making the often impossible appearing arrangements for shipping and crating the exhibit.

The staff of the Oklahoma Museum of Art has for months worked tirelessly at making sure that the exhibition and the multitude of activities surrounding it are handled in a most professional manner. It is beyond doubt that this exhibit could not have occurred without Mary Scurlock, my assistant. Her ease at managing the diverse demands, personalities and cities involved in this project as well as in pointing me in the right direction has been a wonder to behold. Joan Carpenter, the new Assistant Curator of the museum, has been of immense help in organizing and writing many of the events held in conjunction with the exhibition. Her brief introduction to this catalogue provides a useful tool for understanding the multitude of ideas and styles inherent in these works. Rick Duiker, Keith Ann Smith, Jeanne Hollenbeck, David Rust, Barbara Kennedy, Beverly Glover and the rest of the OMA staff have worked tirelessly to insure the success of the exhibit. I and each of the Trustees recognize the professionalism and dedication of the finest fine arts staff in Oklahoma.

Since my arrival in Oklahoma two years ago to assume the Directorship of the museum, the Trustees have been a tremendous support and resource in the development and expansion of the museum's programs, facilities and collections. From the very beginning the Trustees have enthusiastically encouraged the development of *Impressionism/Post-Impressionism* and have gone beyond the call of duty in insuring its success. Their contribution to the cultural life of our community is an example for others to follow and for the community to appreciate. A special note of thanks must go to Mr. Charles Nesbitt, President of the Trustees for his friendship, leadership and constant dedication to the professional development of the museum. It is also a pleasure to extend my thanks to Mr. Richard L. Sias, former President of the Trustees and the first sponsor of *Impressionism/Post-Impressionism*. It was under his leadership that this exhibit was begun. Ms. Ann Felton, Trustee, as well as head of the Lehman Collection Committee, has contributed to the success of this exhibit and its attending programs through her ceaseless efforts, good cheer, novel ideas and organizational wonders. Jo Russell, President of the OMA Volunteer Association, Jeanne Burke, Jeanne Blair, Phyllis Stough, Monika Boganschutz, Ann Hopps, Barbara Fretwell, Virginia Brown, Charlene Barbour, and many of the over 200 other volunteers have been invaluable in making this exhibition a reality.

Lastly, I would like to express a sincere note of appreciation to the sponsors of *Impressionism/Post-Impressionism*, listed in the front of this catalogue. Their patronage of this exhibit has made possible one of the premier cultural events of 1983.

13

INTRODUCTION

Joan Carpenter
Assistant Curator

THE WORKS in this exhibition are masterpieces of a period that was the most momentous in the history of painting. A century of rapid changes in the way artists perceived and interpreted the world separates the earliest picture in the show, Jules Dupré's *Landscape with Cattle* (1837), and Pierre Bonnard's view of Le Cannet (c. 1943-1945). Between Dupré's freshly observed realism and Bonnard's near abstraction came the artistic revolutions of Impressionism, Symbolism, and Fauvism. All these styles, which in large part determined the course of modern painting, are represented here. The variety of artistic expression within this hundred-year time span is truly astonishing.

But, remarkably, we can trace as many informative connections as bewildering disjunctions between the 35 paintings that are included here. Henri-Joseph Harpignies' *Landscape* of 1854, for instance, may at first glance appear to have nothing in common with Georges Braque's *House Behind Trees* of 1906. But if we insert between them landscapes by Alfred Sisley and Paul Cézanne, we begin to see how the pieces of the puzzle fall into place. For all its radical innovation, Braque's painting is the result of a stylistic progression, an ongoing series of developments that, although the result of great creative and personal struggle, now seem logical, even inevitable.

The title of this exhibition is "Impressionism/Post-Impressionism"; in those two words lies the solution to the artistic puzzle of the last century and a half. Taken together, these two extraordinarily fertile movements form the basis of all the painting that has succeeded them, up to our own day, and an understanding of them provides the links that join Braque to Harpignies.

The development of Impressionism in the 1860's by a group of young artists centered around Claude Monet and Pierre-Auguste Renoir marks the beginning of the modern age in painting. Everything in this exhibition — except the Barbizon paintings of Dupré and Harpignies, which are its precursors — comes out of Impressionism in one way or another.

The majority of works in this exhibition are landscapes, and the rest are portraits or pictures of anonymous figures. That fact hardly seems remarkable, and our easy acceptance of it is a sign of one of the artistic revolutions instigated by the Impressionists. Although he revered the art of the past, Renoir reflected that "under Louis the Fifteenth I would have been obligated to paint nothing but specified subjects. And what seems most significant to me about our movement is that we have freed painting from the importance of the subject." By the standards of the late twentieth century, Renoir's landscapes, genre scenes, and nudes seem quite subject-oriented indeed, but in the 1860's they were surprisingly unconventional. As he put it, "I am at liberty to paint flowers, and call them simply flowers, without their needing to tell a story."

Until well after the middle of the nineteenth century, successful artists busied themselves painting incidents from the Old and New Testaments, tales from classical mythology, great events of ancient and medieval history, stirring passages from literature, and scenes of life in

15

exotic locales. Whatever their particular subject, what all of these "history paintings" had in common was that they presented a message. They entertained the public and taught easily digestible lessons in morality and heroic conduct.

Around 1840, however — that is, about the time Jules Dupré painted his *Landscape with Cattle* — a few advanced painters and critics began to demand an art that depicted the life of their own time in a realistic way. Believability and relevance to contemporary existence became important criteria in the choice of subject matter. Portraits, still-lifes, landscapes, and scenes of daily life in the artist's own environment — subjects once considered unworthy of a serious painter's efforts — were called upon to fill the vacuum left by the rejection of the old story-telling subjects.

Along with contemporary subject matter, the random configurations of nature as it is actually experienced were traced for the first time on Impressionist canvases. The Impressionist painter refused to impose the traditional organizational frameworks on inherently disorganized sensory data. He prized perception over conception, and painted things just as he saw them. The Impressionists placed great emphasis on spontaneity — giving in to inspiration and the fleeting impressions of the moment rather than generating complex timeless images by an intellectualized process.

Yet another contribution of Impressionism to subsequent modernist movements was its origination of a stylistic drive that ultimately affirmed the autonomy of painting and its independence from nature. As painting was literally drained of subject matter in the traditional sense, the focus shifted to the artist's interpretation of his relatively uninteresting motifs and to the means of painting itself. Impressionism, with its stress upon the reproduction of every fleck of light in the artist's visual field, marks the height of objectivity in art, but at the same time it fostered the development of acute pictorial and perceptual sensibilities that many later artists would put to far different uses. After Impressionism, the possibilities of Realism seemed, at least temporarily, to be exhausted. The painter no longer wished to be the "ape of nature". He could turn his attention to painting's innate properties of color, design, and two-dimensionality. To reproduce nature became redundant; to create something never before seen was the new role of the artist.

Maurice Denis, the great Post-Impressionist theorist, was well aware of this when he wrote in 1890, "Remember that a picture — before being a war horse, a nude woman or some anecdote — is essentially a plane surface covered with colors assembled in a certain order." Denis' famous definition should be paired with an equally celebrated dictum of Paul Gauguin: "Art is an abstraction. Seek it in nature by dreaming in the presence of it." These simple statements mark out the course of Post-Impressionism and point toward twentieth-century art.

The Post-Impressionists put back into painting a few things that had been lost during the Impressionist revolution, and they added some things that had never been there before. The Neo-Impressionists Paul Signac and Henri-Edmond Cross felt that the Impressionists' liberalism in regard to the essentially disorganized state of the world had gotten out of hand; they resolved to put order back with scientific color theories and pictorial construction by means of little dots. Cézanne insisted upon a reimposition of the artist's knowledge on objective visual experience, and he concluded that getting nature down on canvas was a time-consuming and painstaking process, not an afternoon's employment. Some painters, though grateful that old-fashioned history painting had been dispensed with, lamented the impersonality of Impressionist themes. For van Gogh, Impressionism lacked human feeling; Gauguin found it bereft of symbolic content. And concurrent with Freud's invention of psychoanalysis, Edouard Vuillard created a pictorial analogue for the claustrophobic tensions and ambiguities that underlie middle-class domestic existence.

The Fauves — Matisse, Derain, Vlaminck, Marquet, van Dongen, Braque — succeeded the Post-Impressionists in the early years of this century. The Fauves pushed the simplification and communication of experience by means appropriate to their medium to the extreme. They accomplished their expressive goals by exploiting pure color for its own sake, irrespective of natural appearances. Color is the foundation of Impres-

sionism, of course, but there it is subordinated to representation. In Gauguin's art color served a decorative end, in van Gogh's it had a symbolic purpose, in Cézanne's a structural one — but never before had color been the entire *raison d'être* of a style. The public was outraged by this deformation and arbitrary recasting of reality and readily accepted a critic's nickname for the group — "Fauves", or Wild Beasts.

The idea of calling an artist a "wild beast" is peculiar to the period and highly characteristic. Two situations are implied by such an appellation: that the artist is a being outside the social status quo, and that he is a somewhat primitive character.

As traditional religious and historical subject matter lost its relevance, and as expression displaced imitation as the primary function of painting, the artist's place in society changed as well. Up until the late nineteenth century, the French government and its allies the Church and the aristocracy provided the most profitable employment for artists, who were assigned detailed commissions to carry out in the style prescribed by the official Academy. A highly developed apparatus of art schools, bureaucracies, and exhibitions was in place. Successful artists enjoyed the celebrity and wealth that are associated with successful movie producers today.

We now look back with bemusement on these nineteenth-century French art institutions, but their demise was preceded by a painful period of adjustment, for artists and for the public. With the loss of the old patrons of state, religion, and nobility, the painter's survival depended upon a "market," a vast, unknown, and largely hostile public audience. To the anxieties of being an artist, perhaps the most "ego-intensive" of professions, were added the concerns of the businessman. Embattled isolation is not necessarily inimical to the creation of great works of art — Cézanne and van Gogh certainly disprove that — but it is not the most comfortable way to live out a painter's or any other life.

A few artists professed to welcome this state of affairs, which left them outside society and by extension not subject to its stifling conventions. Maurice Vlaminck, for one, relished the "Wild Beast" label; in his art and life he tried to free himself from social strictures in order to realize a primitivist ideal of purity, simplicity, and directness of expression that has its roots in the writings of the Enlightenment philosopher Jean-Jacques Rousseau.

The thread of primitivism, in a variety of forms, runs through this period. The pastoral subjects of Dupré, Harpignies, and Trouillebert are as much an expression of longing for a return to a simpler, pre-industrial world as Gauguin's Polynesian themes. It is noteworthy how many of the models chosen by figure painters — the county people portrayed by Pissarro and van Gogh, Renoir's anti-intellectual child-women — are emblematic of a less complex existence than that experienced by themselves and their audience.

In style, too, many of these painters exhibit what Matisse called "the courage to return to the purity of means." Cézanne was strongly associated with a primitive, even child-like approach to painting by his contemporaries. Chagall's adaptation of modernist color and pictorial construction to the ends of folk painting, or Rouault's style, which takes medieval stained glass and Rembrandt several steps backward, or Vlaminck's desire to burn down the École des Beaux-Arts with "my cobalts and vermilions" are paradigms of the honesty and authenticity of expression that artistic primitivism represents in our time.

It is thus not surprising that Camille Pissarro could write, with a certain pride,

> "Remember that I have the temperament of a peasant, I am melancholy, harsh and savage in my works, it is only in the long run that I can expect to please, and then only those who have a grain of indulgence; but the eye of the passer-by is too hasty and sees only the surface. Whoever is in a hurry will not stop for me."

We can trace the beginnings of modern art with the pictures in this exhibition. Like all great paintings, they are not for those who are "in a hurry." It takes time to understand and come to value these pictures, as it took time and courage to create them. But what at first appear to be diverse and contradictory aims on the part of these painters with time and understanding resolve themselves into a unity that answers and extends the best traditions in French painting.

IMPRESSIONISM POST-IMPRESSIONISM

XIX and XX Century Paintings from the
Robert Lehman Collection of the Metropolitan Museum of Art

CATALOGUE

Dr. George Szabo
Curator, The Robert Lehman Collection

ALBERT ANDRÉ

(1869-1954)

Renoir and His Model

Oil on canvas, H. 79.4 x W. 99.1 cm. Signed in lower right corner: *Albert André.*

Prov.: Unknown.

Bibl.: The Cincinnati Art Museum. *The Lehman Collection, New York,* exhibition catalogue. Cincinnati, 1959, no. 177, p. 23.

THIS INTIMATE canvas depicts the old artist around 1916, a few years before his death, in his studio on Boulevard Rochechouart, Paris. His son, Jean Renoir, fondly mentions that, "Albert André was the only friend who knew 'the boss' well and understood him completely during the difficult last years." During these last years Renoir was crippled, worked only from his wheelchair, and could hardly grasp the brush. Nevertheless, Renoir did not abandon painting, as shown here by his sympathetic confidant and fellow painter. In spite of the obvious decline of Renoir's health, there are signs of full activity here: the nude model, the paintings on the racks, and the old artist's movements are all captured. *Renoir and His Model* is therefore of great documentary value as well as artistic beauty. It complements and corresponds closely with photographs made of Renoir in his last years.

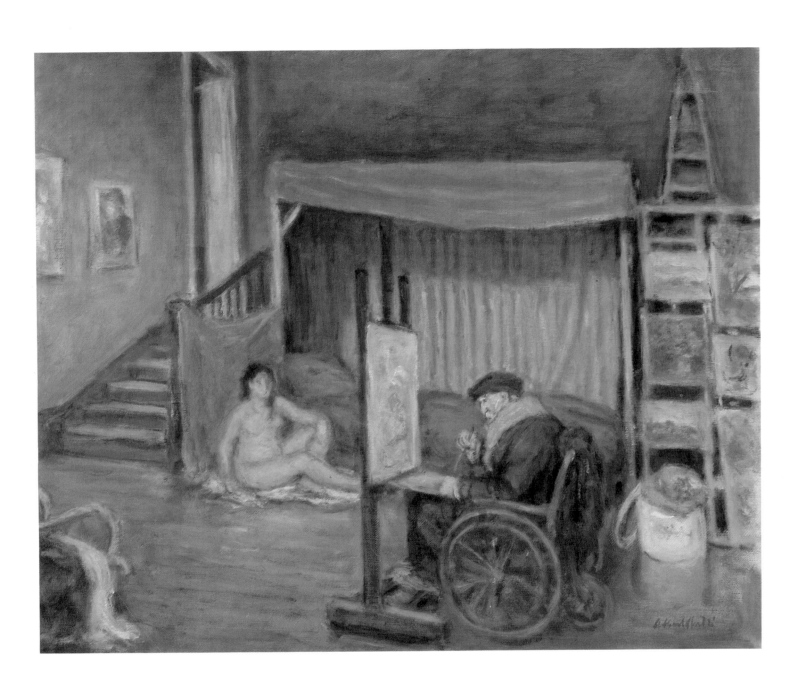

PIERRE BONNARD
(1867-1947)

Landscape in the South: Le Cannet

Oil on canvas, H. 63.5 cm. x W. 71.1 cm. Signed at bottom right: *Bonnard*

Prov.: Galerie Petrides, Paris; Sam Salz, New York.

Bibl.: Laprade, J. de. *Bonnard.* Paris, 1944; Beer, F.-J. *Pierre Bonnard.* Marseille, 1947, p. 148; Dauberville, J. and H. *Bonnard, catalogue raisonné de l'oeuvre peint.* Paris, 1966-1974, Vol. IV, no. 1627; Szabo, G. *The Robert Lehman Collection, A Guide.* The Metropolitan Museum of Art, New York, 1975, no. 115, p. 96; Martin-Mery, G. (Ed.). *Profil du Metropolitan Museum of Art de New York de Ramses à Picasso.* Bordeaux, 1981, no. 151. p. 124.

PIERRE BONNARD, together with Edouard Vuillard, belonged to a small group of painters called *Les Nabis*. Their name was taken from the Hebrew, meaning "prophet", and they assumed it to emphasize the prophetic nature of Gauguin's advice to paint in pure and flat colors. In this spirit a member of the group pronounced: "Remember that a picture, before being a horse, a nude, or some kind of anecdote, is essentially a flat surface covered with color, assembled in a certain order." This implies the rejection of the inherent naturalism of Impressionism and also emphasizes the importance of subject matter. Bonnard remained true to this credo, although he modified it, especially in his later years, as is quite evident in this canvas with the view of Le Cannet from the garden of his villa painted between 1943-1945.

At the beginning of World War II, the artist retired to this villa, called "Le Bosquet", which he had acquired in 1925. His nephew described it fondly as "a little house with pink walls, all white on the inside. The garden, where bushes and flowers grow at will, slants down to the street. At a distance one can see the red roofs of Le Cannet, the mountains, the sea." This painting was probably done outside the house, and one of Bonnard's visitors from these last years remembers seeing similar canvases lined up against the wall as the artist put various colors on them, one by one. The garden is in late spring bloom, and farther down the red roofs are also distinguishable. There is great freedom and enjoyment in this landscape, in the far-reaching vista and the brilliant colors. With hundreds of small brushstrokes, the innumerable color spots are arranged into horizontal layers representing the shoreline, the shallow and then the deeper water, and finally the distant sky. The cold and hot tones, the contrasting light and shadow define every element of the vibrant landscape.

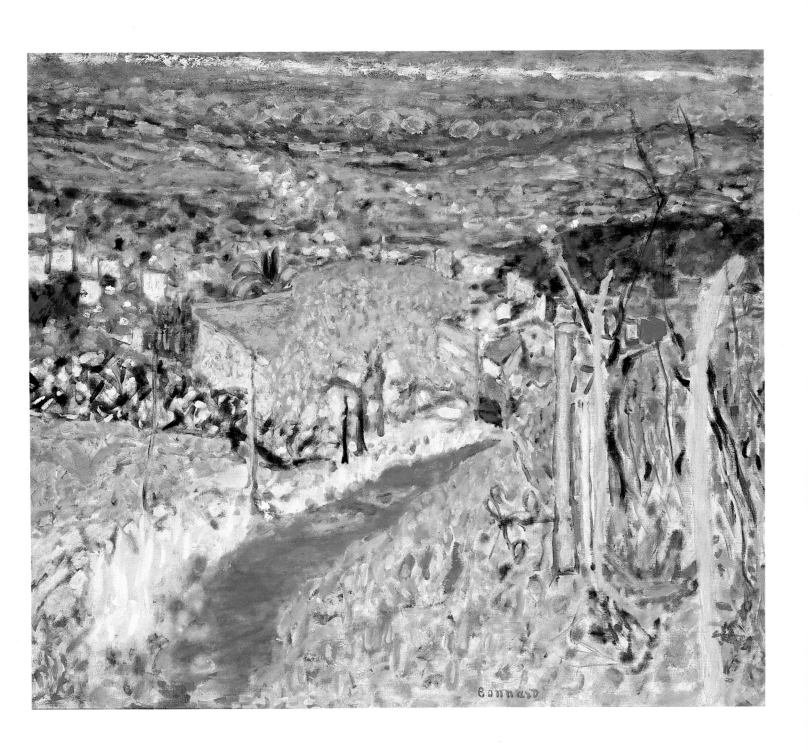

GEORGES BRAQUE
(1882-1963)

House Behind Trees

Oil on canvas, H. 37.5 cm. x W. 45.7 cm. Signed at lower right: *G. Braque*

Prov.: Purchased in Paris in the early 1950s

Bib;.: Museum of Modern Art. *Les Fauves,* exhibition catalogue. New York, 1953, no. 15; Musée de l'Orangerie. *Exposition de la Collection Lehman de New York,* exhibition catalogue. Paris, 1957, no. 62; Sindona, E. *Galleria della Pittura Europea.* Milano, 1961, p. 235-236; Crespelle, J.P. *Les Fauves.* Geneva, 1962, pl. 53; Müller, J.E. *Fauvism.* New York-Washington, 1967, p. 132-133, fig. 134; Szabo, G. *The Robert Lehman Collection, A Guide.* The Metropolitan Museum of Art, New York, 1975, no. 109, p. 95; Martin-Mery, G. (Ed.). *Profil du Metropolitan Museum of Art de New York de Ramses a Picasso.* Bordeaux, 1981, no. 152, p. 124-125.

ALTHOUGH THE painting is not dated it clearly belongs to a series of canvases that Braque painted around 1906 in l'Estaque, a town in the South of France near Marseille. The bold colors and strong strokes of the brush are characteristic of the artist's early Fauve style. The term "Fauve" has an interesting origin. At the Paris *Salon d'Automne* of 1905, the works of Matisse, Marquet, Derain, Vlaminck, Rouault and Braque were hung together in one room. The violent colors, flat patterns and bold distortion of forms and perspective created a furor among the visitors. A critic dubbed them *"les Fauves"* ("The wild beasts") and the name was permanently attached to them although they never constituted a coherent group. In this early work by Braque the pure scale of strongly contrasting and vivid blues, greens, pinks, reds and yellows clearly indicate the Fauve rebellion against preceeding styles of French painting. However the rhythmic pattern of the branches and their contrast against the calm of the background belies the influence of Cezanne, who also painted at l'Estague. The artist's future development is forecast as the branches in this painting form geometric compartments filled with strong colors. In 1907 he abandoned the *fauve* style, "the short movement of his youth", and devoted himself to Cubism.

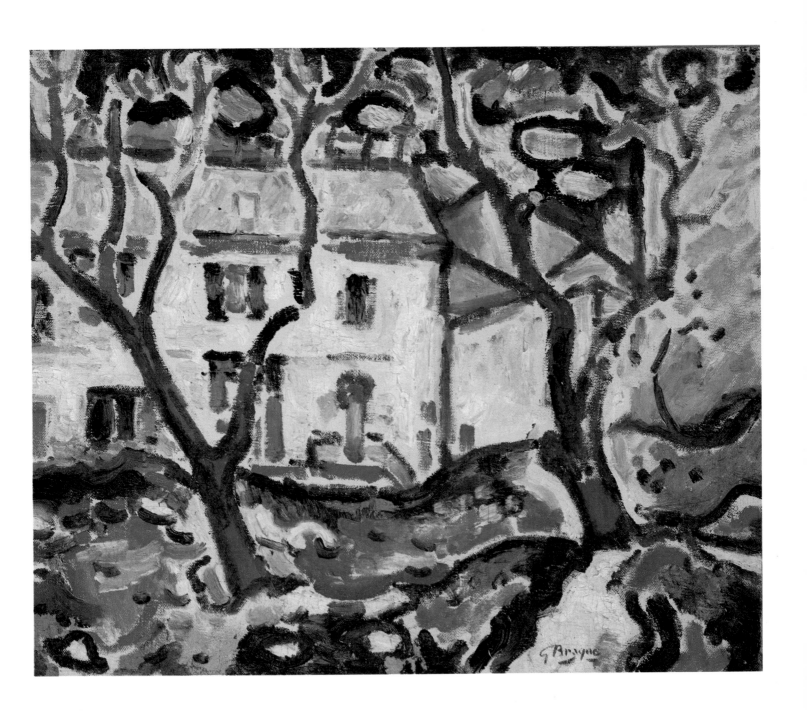

PAUL CÉZANNE
(1839-1906)

House Behind Trees on the Road to Tholonet

Oil on canvas, H. 68 cm. x W. 92 cm.

Prov.: Collection of Ambroise Vollard, Paris; Collection of Paul Guillaume, Paris; Collection of Brandon Davis, London; Collection of Gabriel Cognacq, Paris; Sam Salz, New York.

Bibl.: Venturi, L. *Cézanne, son art - son oeuvre.* Paris, 1936, no. 479; Auzas, P. M. *Peintures de Paul Cézanne.* Paris, p. XI; Dorival, B. *Cézanne.* Paris, 1948, no. 83; Heinrich, T. A. "The Lehman Collection," *The Metropolitan Museum of Art Bulletin, 12* (1954), pp. 224, 232; Musée de l'Orangerie. *Exposition de la Collection Lehman de New York,* exhibition catalogue. Paris, 1957, no. 63, pp. 51-52; Musée National d'Art Occidental. *Exposition Cézanne,* exhibition catalogue. Tokyo, 1974, no. 35; Szabo, G. *The Robert Lehman Collection, A Guide.* The Metropolitan Museum of Art, New York, 1975, no. 85, pp. 92-93.

ALTHOUGH THE canvas is not signed and is only roughly dated to 1885-86, it is a true manifestation of Cézanne's art, a masterpiece, and an excellent example of his credo: "I try to render perspective solely by means of color . . . the main thing in a picture is to achieve distance, by that one recognizes a painter's talent."

This monumental landscape was painted on the outskirts of Aix-en-Provence, where Cézanne spent most of his life. Apparently, the mountainous landscape of Provence, with its barren mountains, tall trees, and blue sky, provided the best surroundings for testing and perfecting his revolutionary method. The trees and the house behind them received the most summary treatment. The colors put on with broad strokes are basic: the ochres and reds, in accord with his beliefs, have the same value in the right foreground as on the roofs of the houses. But despite this simplification, there is no attempt to arrange the forms into patterns, not even in the intertwining boughs of the trees. The basic principle of Impressionism — the representation of nature — is adhered to, but in a different manner. For instance, in Renoir's *Young Girl Bathing* (Catalogue p. 63), the artist's impressions are broken up into "myriads of tiny tints", while here they are compressed into larger forms of basic colors. The former method eventually led to the "pointillists" (who painted in minute dots), while Cézanne's technique very much influenced the Fauves.

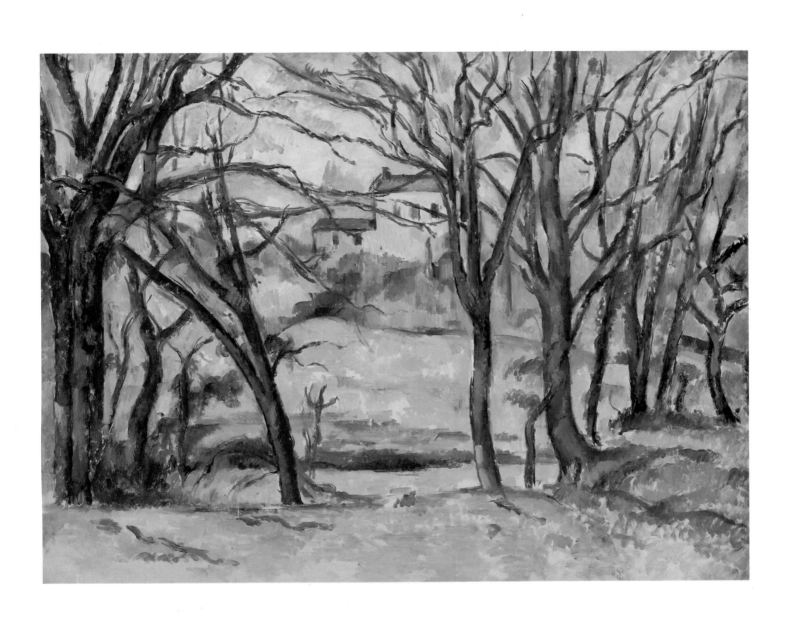

MARC CHAGALL
(Born 1887)

Le Pont de Passy and the Eiffel Tower

Oil on canvas, H. 59.6 cm. x 81.3 cm. Signed and dated in bottom center: *Marc Chagall 1911.*

Prov.: Collection of Dr. Witzinger, Basel.

Bibl.: Meyer, F. *Marc Chagall, Leben und Werk.* Cologne, 1961, pp. 109-147. pl. no. 42.

PAINTED DURING his first visit to Paris in 1911, the painting demonstrates the powerful impact of the metropolis on Chagall and his longing for his native city of Vitebsk in Russia. The pictorial field is divided with strong diagonals of line and color. As befitting the Eiffel Tower — the highest artificial structure in the world in 1911 — it dominates the painting. But the little horse in the left corner is a reminder of home, of the simple, down-to-earth life in the small towns of Russia. Memories like these always crept into Chagall's paintings from his Parisian years (1910-1914), despite the hectic life he lived and the avant-garde influences of his friends at the famed *"La Ruche"*. In this ramshackle building Modigliani had his studio next to Chagall's, and both were visited by poets such as Apollinaire or Cendrars.

Even after his return to Paris in 1923, "Chagall rarely lost sight of the Vitebsk of his boyhood, even though the yellow houses . . . and the interminable wooden fences might at times become chaotically scrambled in his pictures with the Eiffel Tower and the Champ de Mars."

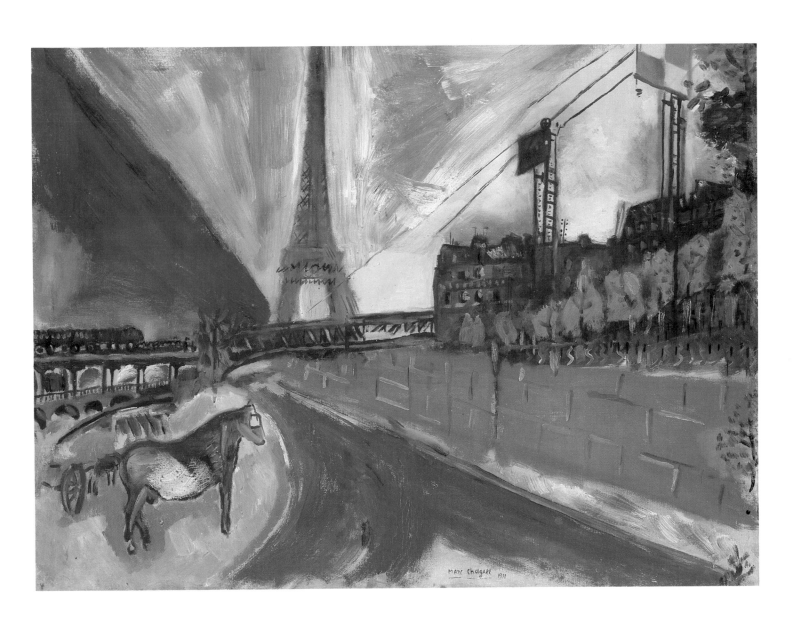

HENRI-EDMOND CROSS
(1856-1910)

Valley with Fir

Oil on canvas, H. 73 cm. x W. 92 cm. Signed and dated in lower left corner: *Henri Edmond Cross 09.*

Prov.: Galerie Bernheim-Jeune, Paris; Collection of M. Jossé Bernheim, Paris.

Bibl.: Fénéon, F. "Le dernier carnet d'H. E. Cross", *Bulletin de la Vie artistique,* (May 1922), p. 229; Compin, I. *H. E. Cross. Paris, 1964, no. 224, p. 331; Szabo, G. The Robert Lehman Collection, A Guide.* The Metropolitan Museum of Art, New York, 1975, no. 108, p. 101.

CROSS BELONGED to the circle of Seurat and Signac, but he was a latecomer to Neo-Impressionism and "pointillism". Only in 1891, when he settled in the South of France at Saint-Clair, did he first paint in this style. As this canvas was painted between September 1908 and April 1909, it is a late work. It still shows, however, the character of Cross and his individual use of the technique. There is a careful harmonization of the different color values; the hues of yellow, lavender and blue are brought together with firm, even strokes. In contrast to Signac's work, the human presence is emphasized by Cross, with the inclusion of the figure of a woman in the lower right corner.

Valley with Fir represents the full flowering of Cross's art and was admired by his fellow artists. Lucie Cousturier wrote the following sensitive appreciation of his paintings: ". . . it is contrasts which abound; without waiting for the conventional heavy foregrounds, a red peak throws against the yellow-green sky its eloquent phrase dominating both the poignant clamors of sulfer trees which are irritated by pink, and shaded by ultramarine blue, and also orange trees shaded with green and blue-green, underlined by cherry pink and purple . . . It is everything modern music has found of the rarest and boldest in dissonances and postponed resolutions. It is no longer a rendering of light, trees or soil, it is a bold transposition of these into the abstract language of tints, in which each, in different degrees excited, solidified, weakened, possesses infinite expressive virtues."

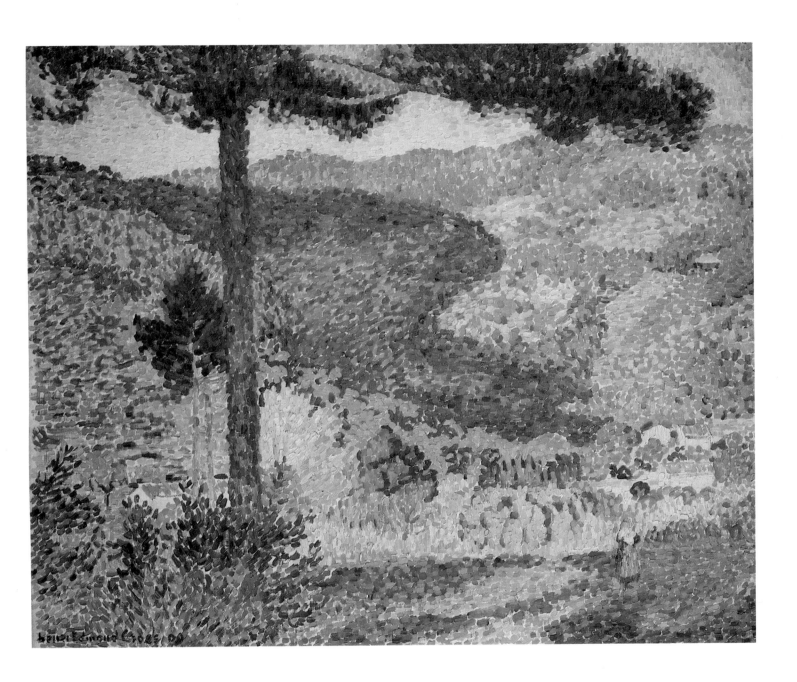

EDGAR HILAIRE GERMAIN DEGAS
(1834-1917)

Landscape
Oil on canvas, H. 51 cm. x W. 61 cm.

Prov.: Mademoiselle J. Fevre, niece of Degas, Paris.

Bibl.: Musée de L'Orangerie. *Exposition de la Collection Lehman de New York,* exhibition catalogue. Paris, 1957, no. 65, p. 52; Szabo, G. *The Robert Lehman Collection, A Guide.* The Metropolitan Museum of Art, New York, 1975, no. 100, p. 100; Edgar Degas, Acquavella Galleries, *Edgar Degas,* exhibition catalogue. New York, 1978, no. 53.

L*ANDSCAPE* IS a rare and unusual painting by Degas, an artist well known for his sensitive depictions of ballet dancers and stylish ladies. Degas painted the view of the peaceful, small town of Saint-Valéry-sur-Somme where he stayed with his brother René in 1898. Together with his painter friend, Braquaval, the artist explored the landscape and recorded it not only in paintings and drawings but also in photographs. The colors are fresh and pastel-like, capturing the sunlit reds, ochres, and yellows of the houses, their black contours overlaying a subtle network of geometric forms. This is reminiscent of the shapes and patterns in Cézanne's paintings and may forecast the style of Fauve landscapes such as Braque's *Houses Behind Trees,* in this exhibition (Catalogue p. 25). Most of Degas' landscapes are in monotype, and this subject is very rare in the artist's painted oeuvre. This canvas is outstanding furthermore because of the predominance of red and ochre in contrast to the blues and purples of many of Degas' paintings.

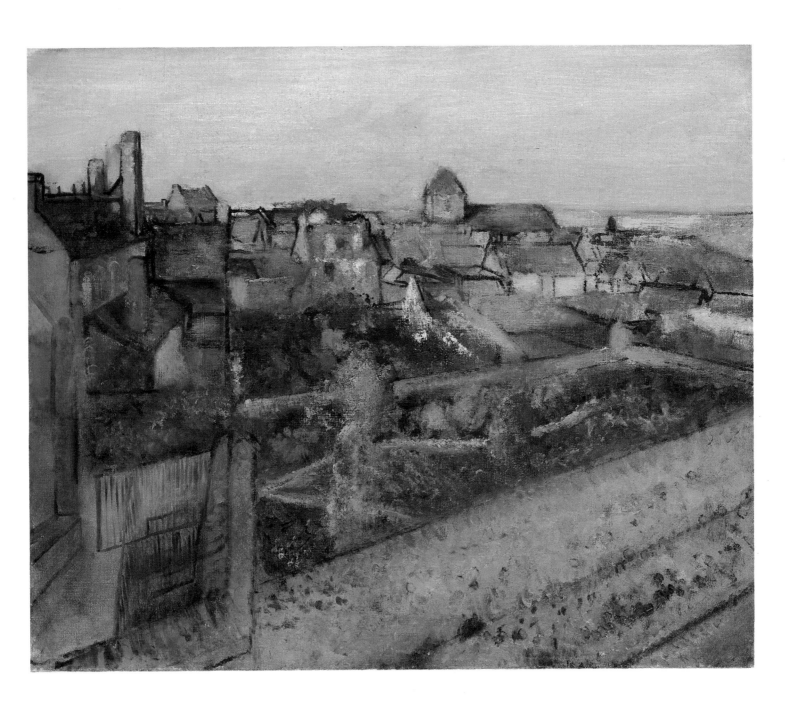

ANDRÉ DERAIN
(1880-1954)

The Houses of Parliament at Night

Oil on canvas, H. 78.7 cm. x W. 99.1 cm. Signed in lower right corner: *Derain*.

Prov.: Collection of Ambroise Vollard, Paris; Collection of John Quinn, New York.

Bibl.: Musée de l'Orangerie, *Exposition de la Collection Lehman de New York*, exhibition catalogue. Paris, 1957, no. 66, pp. 52-53; Hilaire, G. *Derain*. Paris, 1959, p. 91, no. 34; Leymarie, J. *Le Fauvisme*. Geneva, 1959, p. 97; Crespelle, J.-P., *Les Fauves*. Geneva, 1962, pl. 32; Szabo, G. *The Robert Lehman Collection, A Guide*. The Metropolitan Museum of Art, New York, 1975, pp. 95-96, no. 107; The National Maritime Museum, *London and the Thames: Paintings of Three Centuries*, exhibition catalogue. London, 1977, no. 110; Martin-Mery, G. *Profil du Metropolitan Museum of Art de New York de Ramses à Picasso*. Bordeaux, 1981, no. 155. pp. 125-126.

ALTHOUGH IT is not dated, we know from the artist's recollections that he painted this strong Fauve canvas during one of his two visits to London, either in the latter part of 1905 or early in 1906. Both visits were made on the suggestion and with the financial help of the dealer Ambroise Vollard, who was encouraged by the success of Monet's paintings of London from 1900. Derain explained later: "M. Vollard . . . had sent me to London at that time so I could make some paintings for him. After a stay in London he was very enthusiastic and wanted paintings inspired by the London atmosphere. He sent me in the hope of renewing completely at that date the expression which Claude Monet had so strikingly achieved, which has made a very strong impression on Paris in the preceding years." This striking painting is masterful in its composition, technique, and most of all in its dramatically vibrant colors. The pictorial field is divided into two equal sections by the diagonal of the Parliament's shoreline. The upper half is split again by the use of contrasting brushstrokes and colors. The short blue verticals and horizontals characterize the building, the wider curving strokes the shapes and movements of the sky. Derain repeated this pattern in depicting the water of the Thames. The section close to the shore is done with parallel strokes while the large expanses of the water in mid-stream around the heavy barges are represented with long, flowing ones. This juxtaposition of rhythm, stroke and color imbues the painting with an extraordinary sense of movement and drama. In this, Derain not only followed the footsteps of Claude Monet, who had painted the Houses of Parliament many times, but also recorded the scene with a new artistic vocabulary, orchestrated with the energetic spirit that became the hallmark of Fauvism.

The importance of this painting was recognized early on. It was purchased from Vollard by the pioneer American collector John Quinn of New York. Since Robert Lehman acquired it in 1948, it has also been shown in almost every important exhibition of Derain's oeuvre or that of the Fauves.

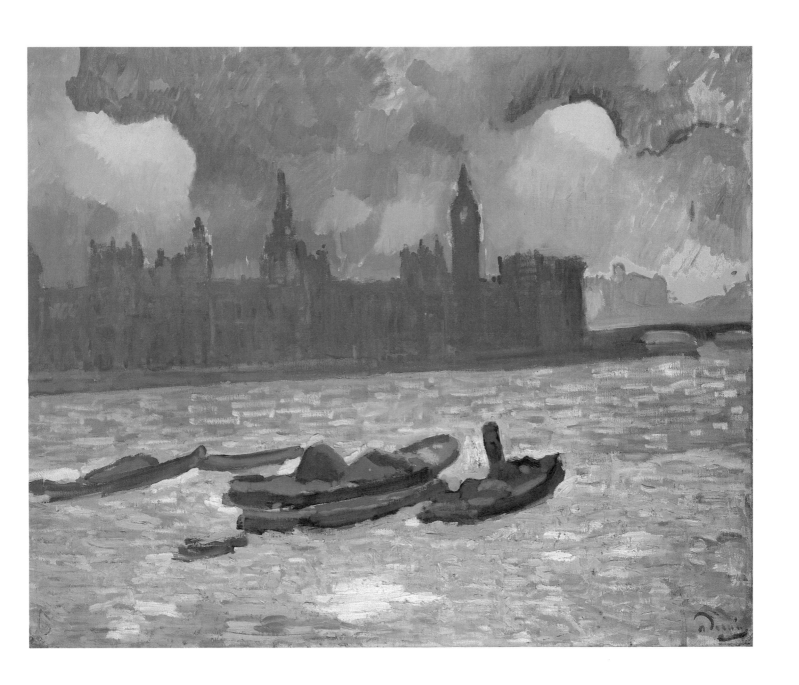

KEES VAN DONGEN
(1877-1968)

Avenue du Bois

Oil on canvas, H. 81 cm. x W. 100 cm. Signed in lower right corner: *Van Dongen.*

Prov.: Mme S. (Signac), Paris.

Bibl.: The Cincinnati Art Museum, *The Lehman Collection, New York,* exhibition catalogue. Cincinnati, 1959, no. 183, p. 23; Szabo, G. *The Robert Lehman Collection, A Guide.* The Metropolitan Museum of Art, New York, 1975, no. 117, p. 102.

VAN DONGEN was the Fauve who best deserved the name, for he remained true to the use of vivid colors throughout his career. In his works these vivid colors are used to stress more than just corcondance or clash but are treated as constructive elements. Although Dutch by birth, he was probably more Gallic than his French artist friends, a fact beautifully demonstrated by this canvas painted around 1925.

According to a penciled inscription by the artist on the stretcher, *Avenue du Bois* represents a Sunday morning on the favorite Parisian strolling place. His Fauve heritage is in full force and even more sophisticated is the organization of the composition that includes the *Arc de Triomphe,* a throng of people and automobiles, and a smattering of old-fashioned horsemen and stylish sportscars. Each of these components is depicted with a different brush-stroke — the nervous short verticals and horizontals in the center emphasize the character of the briskly moving traffic and strollers.

The canvas is also a precious document of costume, transportation and the general atmosphere of Paris in the 1920's. This was the time and the city that Robert Lehman also loved so much. As he knew van Dongen quite well, this painting occupied a special place not only in his collection but in his heart as well.

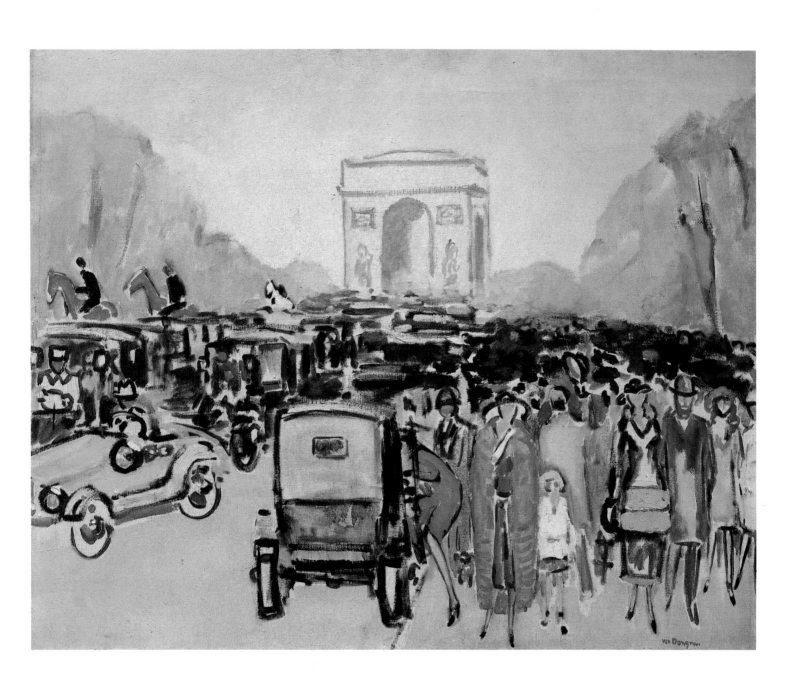

JULES DUPRÉ
(1811-1889)

Landscape with Cattle

Oil on canvas, H. 78.8 cm. x W. 130.8 cm. Signed and dated in lower left corner: *J. Dupré 1837.*

Prov.: Unknown.

Bibl.: Unpublished.

DUPRÉ BECAME associated with the painters of the Barbizon School in the 1830s. This large canvas demonstrates his acceptance of their credo to paint nature as it is, without beautifying it but trying to capture its beauty. In this respect the painters in the Barbizon Forest were the predecessors of the Impressionists.

The large expanses of light sky and the clump of weatherbeaten trees dominate *Landscape with Cattle.* The small figures of cattle and a shepherdess not only add dots of color but also further emphasize the overwhelming expanse of nature.

The first thoughts for this oil painting are in a small colored chalk drawing from 1834, now in a private collection. Its title indicates that the scene depicted here is in the Limousin. Interestingly enough, the drawing is also a preparatory study for Dupré's first lithograph, dated 1835. All three underline the importance that the artist attributed to this composition, which apparently was given final and elaborate form in the present painting.

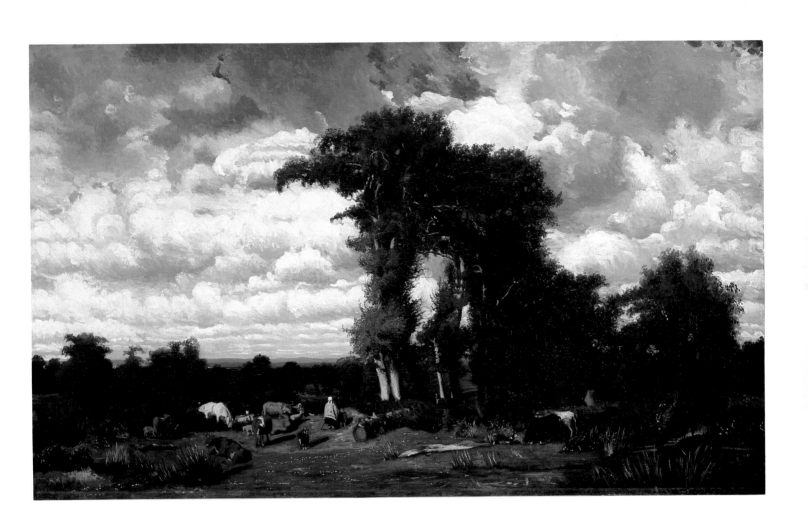

GEORGES d'ESPAGNAT
(1870-1950)

Girl Painting at an Easel

Oil on canvas, H. 65.7 cm. x W. 81.3 cm. Signed in lower left corner with initials: *G d E.*

Prov.: Unknown.

Bibl.: Unpublished.

BEGINNING WITH his early successes, Georges d'Espagnat always considered himself an "independent" artist. His canvases are forceful and bold, yet always have an intimacy that parallels that of Vuillard's pictures. This painting from the 1920's exemplifies his unique artistic personality well. The balanced composition with the girl painting is filled with large fields of colorful patterned fabrics and parts of a large painting in the background. The young painter's subject is also a reminder of d'Espagnat's passion for flower and fruit still-lifes for which he was also well-known and appreciated. The sensitivity of the girl's figure is reminiscent of Renoir's *Young Girls at the Piano* (Catalogue p. 65), while the strong colors show the influence of the Fauves.

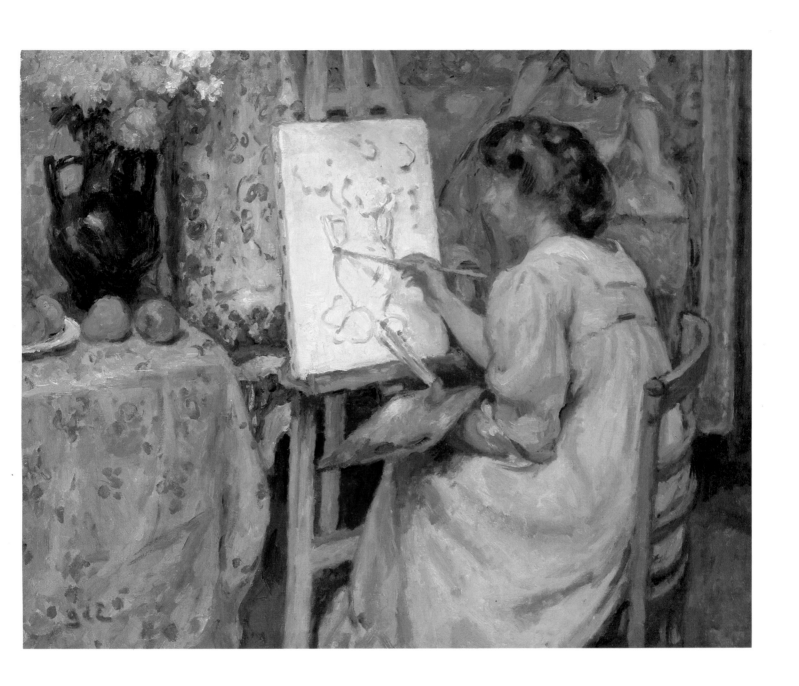

PAUL GAUGUIN
(1848-1903)

Tahitian Women on the Beach

Oil on canvas, H. 110 cm. x W. 89 cm. Signed in lower right corner: *P. Gauguin.*

Prov.: Collection of Ambroise Vollard, Paris; Collection of Alphonse Kann, Paris; Private Collection, London; Collection of Mrs. Josiah Marvel, Philadelphia.

Bibl.: Wildenstein, G. *Gauguin, catalogue raisonné.* Paris, 1964, no. 462; Szabo, G. *The Robert Lehman Collection, A Guide.* The Metropolitan Museum of Art, New York, 1975, no. 97, p. 99; "Gauguin pa Tahiti", Louisiana *Revy,* 23, no. 1 (Oct. 1982): pp. 27, 54.

ALTHOUGH THERE is no date on this painting, it is evident that Gauguin painted it in 1891 or 1892 in Tahiti. There are many comparable dated paintings by him from this period, the most important of which, also in the Metropolitan Museum of Art, is *Ia Orana Maria — Ave Maria* (dated 1891), a gentle and colorful composition usually considered one of Gauguin's major Tahitian works.

In contrast, *Tahitian Women on the Beach* is a forceful, almost violent painting. The canvas is populated with massive sculptural figures and densely covered with clashing fields of strong colors. The artist paid little attention to modeling; in fact, the arms of the standing woman are out of proportion. Despite its daring treatment of the human figure and its violent colors, this painting has exerted a considerable influence on many artists and become an important part of the fabric of French art at the turn of the century.

The whole composition, and especially the standing nude, is very close to Puvis de Chavannes's large canvas of 1879 in the Louvre, *Young Girls at the Seashore.*

This emphasizes Puvis as one of the main influences on Gauguin's art. In turn, the *Tahitian Women on the Beach* probably played an important role in the creation of Henri Matisse's series of bas-reliefs called the *Backs.* It is now accepted that *Back III* especially recalls Gauguin's standing nude. One author has noted, "Matisse must have known the painting; it belonged to Ambroise Vollard and then to Alphonse Kann (Paris), with both of whose collections he was quite familiar." Outside of France, this painting was also influential. As was recently pointed out, the standing nude is "the actual source" for Franz Marc's *Blue Horse II* painted in 1911. The German artist saw the Tahitian painting at a major Gauguin retrospective in August of 1910 in Munich and was "stimulated not only by Gauguin's aesthetic innovation of a color scheme in pure yellow-brown, blue, green and red, but also by the zigzag of Gauguin's water course, which becomes, in the Marc, a mountain path climbing actively back and forth . . . it is harder to imagine an image closer to the French painting than this German one."

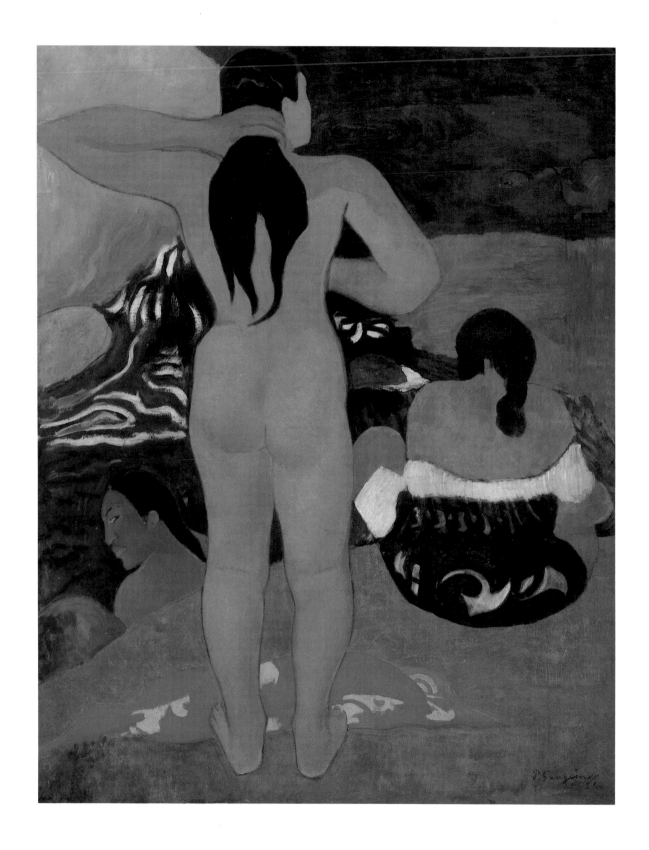

VINCENT VAN GOGH
(1853-1890)

Madame Roulin and Her Baby

Oil on canvas, H. 65 cm. x W. 51 cm.

Prov.: Collection of P. von Mendelssohn-Bartholdy, Berlin; Galerie E. Blot, Paris.

Bibl.: de la Faille, J. B. *L'oeuvre de Vincent van Gogh.* Paris, 1928, Vol. I, no. 491; Scherjon, W. and de Gruyter, J. *Vincent van Gogh's Great Period.* Amsterdam, 1937, Arles no. 130; Shapiro, M. *Vincent van Gogh,* New York, 1950, p. 86; Leymarie, J. *Van Gogh.* Paris, 1951, pp. 119-120; The Cincinnati Art Museum. *The Lehman Collection, New York,* exhibition catalogue. Cincinnati, 1959, no. 189, p. 24; Classici del arte. *L'opera pittorica completa di van Gogh.* Milan, 1966, Vol. II, no. 617; Roskill, M. *Van Gogh, Gauguin and the Impressionist Circle.* New York, 1970, pp. 54-55, no. 156; Szabo, G. *The Robert Lehman Collection, A Guide.* The Metropolitan Museum of Art, New York, 1975, pp. 98-100, no. 96; Huelsker, J. *The Complete van Gogh.* New York, 1977, p. 377, no. 1638; Shapiro, M. *Vincent van Gogh.* Garden City, New York, 1980, p. 86. The Dixon Gallery and Gardens. *The Genius of Van Gogh.* Memphis, Tennessee, 1982, no. 15, pp. 40-41.

THE PORTRAIT of Madame Roulin and her baby is neither signed nor dated, but we know from van Gogh's correspondence to his brother that in November and December 1888 he " . . . made portraits of an entire family, that of the postman whose head I did previously — the husband, the wife, the baby, the younger son and the sixteen-year old son; all with personality and truly French." The baby, called Marcelle, was three months old at the time, and both she and her mother must have been frightened by the artist. This is no wonder, for the year 1888 was a difficult one for van Gogh. He painted feverishly in Arles, sustaining himself on small amounts received from his brother Théo. This was also the time of Gauguin's visit to Arles; its terrible consequences marked the beginning of the artist's end and led to his tragic death.

Despite all this, the canvas is full of friendly yellows and hopeful greens. The baby's unpleasant grin is compensated for by the beautifully drawn profile of her mother. Tension may be observed, however, in the nervous spread of her supporting fingers and in the abrupt modeling of the baby's thumb. The color scheme of the painting is also refined — sensitively placed touches of flesh color, purplish red, and black provide contrasts, subtle exchanges and echoes. In Meyer Shapiro's words: "In its simplicity and power of elementary contrasts, in its inspired freedom of drawing, this painting could be of the twentieth century. As we follow the broken intensely mobile silhouette of mother and child, we discover a basic realism, a direct probing vision of live individuals, which is central in van Gogh."

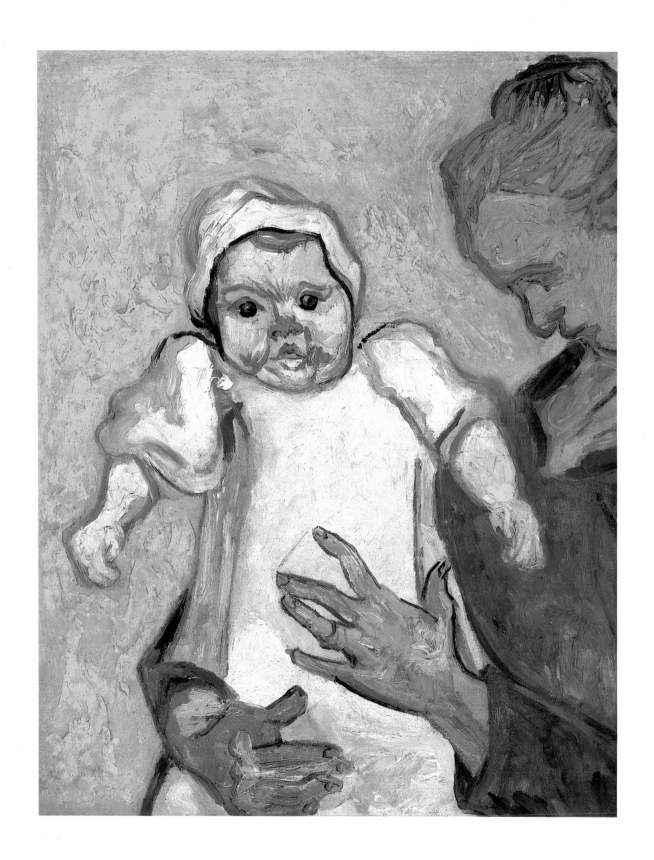

ARMAND GUILLAUMIN
(1841-1927)

The Lock at Genetin

Oil on canvas, H. 65 cm. x W. 81 cm. Signed in lower left corner: *Guillaumin.*

Prov.: Unknown. Purchased from the Galerie Renou et Poyet in Paris in 1964.

Bibl.: Unpublished.

ALTHOUGH THIS canvas bears no date, similar landscapes representing the same Bouchardon mill and the lock at Genetin are dated by the artist himself to October 1913. The tranquil but colorful location is near the village of Crozant, not far from Limoges, where in the last decades of his life Guillaumin spent a considerable amount of time. He was a contemporary of the Impressionists and exhibited in the *Salon des Refusés,* but this painting is rather closer to the broad strokes and pure colors of the Fauves. In 1886, Félix Fénéon, friend and critic of generations of French painters, wrote the following about his paintings: "Under the sumptuous skies are anchored, painted by brutal *empâtements,* violet countrysides . . . trees rustle on the slopes fleeing toward some houses . . . the undulating reflections of the little river amplify themselves in ellipses which carry away the renascent water . . . this is a furious colorist, beautiful painter of landscapes gorged with sap."

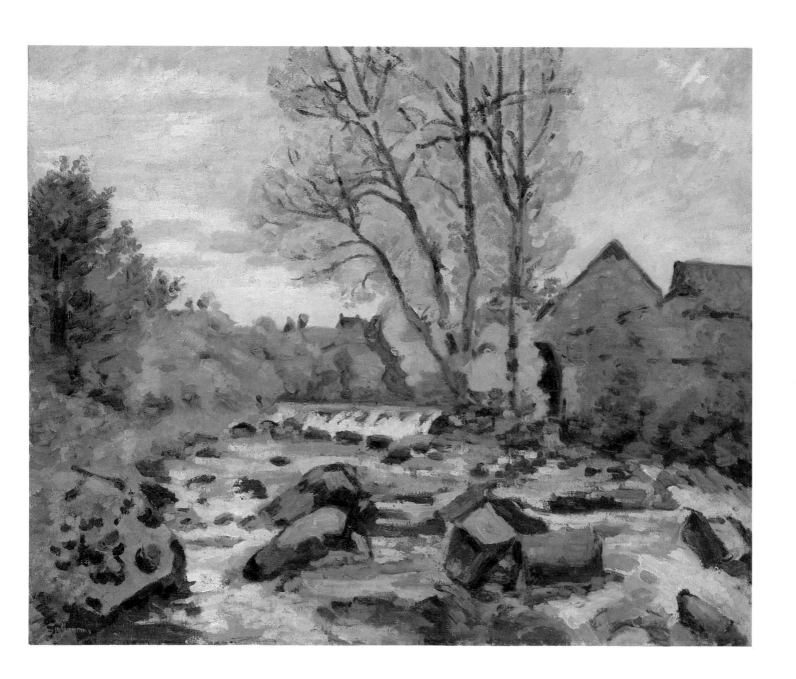

HENRI-JOSEPH HARPIGNIES
(1819-1916)

Landscape

Oil on canvas, H. 41 cm. x W. 32 cm. Signed and dated in lower right corner: *H. Harpignies 1854*

Prov.: Unknown.

Bibl.: Szabo, G. *The Robert Lehman Collection, A Guide.* The Metropolitan Museum of Art, New York, 1975, p. 97, no. 85.

HARPIGNIES BEGAN to draw at the age of five, and after extensive study trips to Germany and Italy he entered the Salon in 1853 with three paintings. He probably met Corot in the same year, and the older artist's style affected Harpignies' for the rest of his long life. However, he always remained faithful to his individual interpretation of nature, resisting the forces of Impressionism and Fauvism.

In the archives of the Robert Lehman Collection there is a photograph of this painting which the artist inscribed in November 1910 with the following description: "I certify that this painting was painted by me in 1854 . . . this work was painted solely after nature." The artist also noted that the scene represents fir trees near Marlotte.

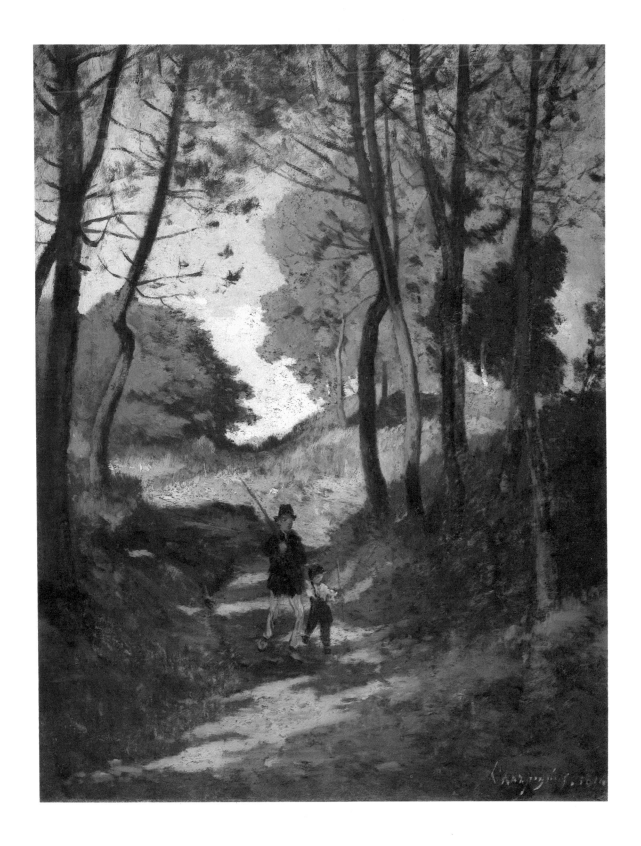

HENRI-JOSEPH HARPIGNIES
(1819-1916)

Landscape

Oil on canvas, H. 95.5 cm. x W. 160.4 cm. Signed and dated in lower left corner:: *H J Harpignies 1869.*

Prov.: Unknown.

Bibl.: Unpublished.

THIS LANDSCAPE is from one of the strongest periods of the artist's long career. The dark and rocky foreground with the little path and the patch of light sky behind the dark trees are all hallmarks of his art. Nature's dominance is hardly affected by the figures of three children standing among the rocks like little puppets.

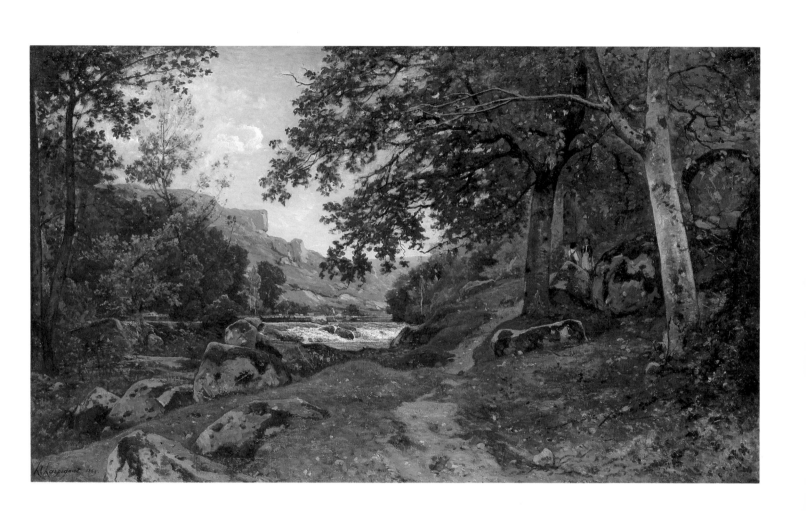

GUSTAVE LOISEAU
(1865-1935)

La Place de la Bastille

Oil on canvas, H. 61 cm. x W. 73 cm. Signed and dated in lower left corner: *G. Loiseau 1922.*

Prov.: Unknown. Purchased from Chapelin Gallery, Paris.

Bibl.: Galerie Durand-Ruel, *Gustave Louiseau,* exhibition catalogue. Paris, 1963, no. 33.

LOISEAU FOLLOWED Gauguin to Pont Aven in 1890 and was attached to various groups of the Post-Impressionists. However he soon developed his own style, characterized by the use of interlocking quick brush-strokes that create an intricate, lattice-like surface on the canvas. He became famous as a great voyager, painting a great diversity of landscapes. In spite of these travels, his native Paris remained a constant subject for him. Here the *Place de la Bastille* is shown on a summer day with the glittering surfaces of the bronze column, the pavement, and the brilliant blue sky.

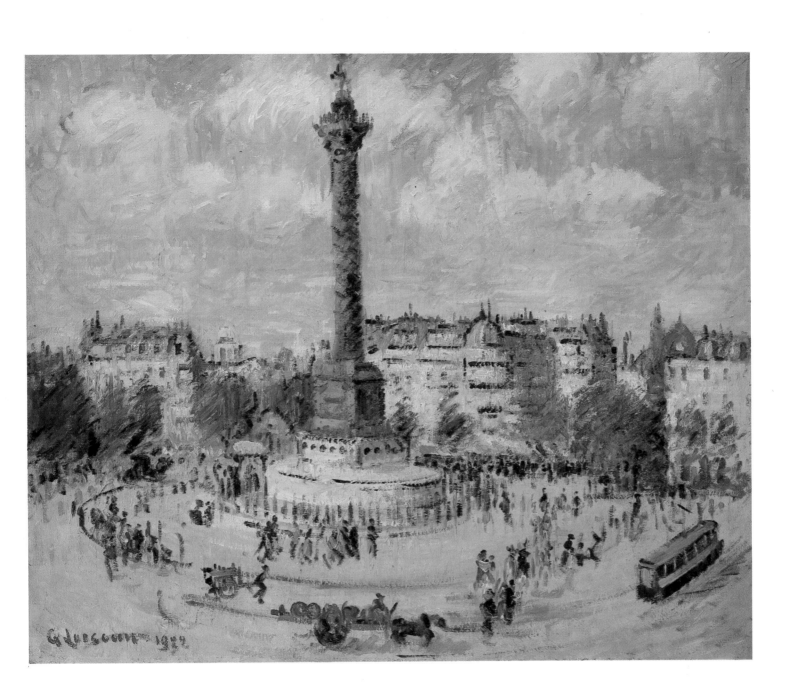

ALBERT MARQUET
(1875-1947)

Sargeant of the Colonial Regiment

Oil on canvas, H. 90 cm. x W. 71 cm. Signed in lower right corner: *Marquet.*

Prov.: Madame Albert Marquet, Paris.

Bibl.: Besson, G. *Marquet.* Paris, n.d., pl. XXII; Rewald, J. *Les Fauves,* The Museum of Modern Art, New York, 1953, no. 78, p. 46; Musée de l'Orangerie, *Exposition de la collection Lehman de New York,* exhibition catalogue. Paris, 1957, no. 69, p. 54; Müller, J.E. *Fauvism.* New York-Washington, 1967, pp. 96, 100-101; Szabo, G. *The Robert Lehman Collection, A Guide.* The Metropolitan Museum of Art, New York, 1975, p. 100, no. 111; Adhémar, H. and Martin-Mery, G. *Albert Marquet.* Paris-Bordeaux, 1975, p. 90.

THIS IMPOSING and lively canvas is considered one of the most important Fauve portraits. Although not dated, this and a slightly smaller version without the cap (now in Bordeaux) are thought to have been painted in 1906-1907. The characterization and monumentality of the figure are in the best tradition of French portraiture; its economy of form is reminiscent of Manet while the bold use of colors shows the influence of Gauguin. However, the slightly bent figure, the almost unvaried black of his uniform, and the strong strokes defining the shape of the face are entirely different from earlier French portraits. The painting also has a special place in the artist's oeuvre; he executed only a few portraits after this one and is better known as a painter of sensuous nudes and colorful landscapes and cityscapes.

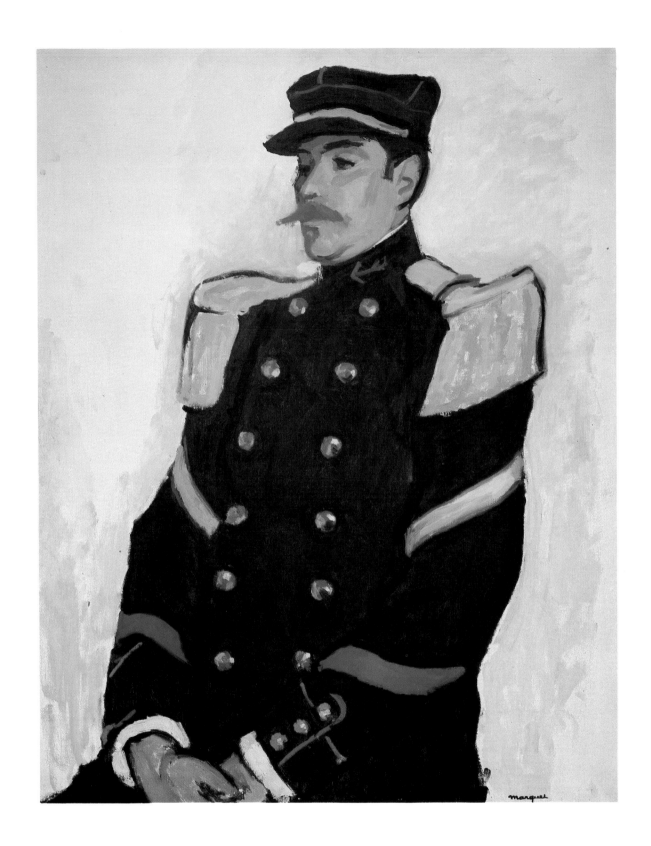

HENRI MATISSE
(1869-1954)

L'Espagnole (Harmonie en bleu)

Oil on canvas, H. 47 cm. x W. 35.5 cm. Signed in lower right corner: *Henri Matisse.*

Prov.: Collection of Gaston Bernheim de Villers, Paris.

Bibl.: Salmon, A. *Henri Matisse.* Paris, n.d., reprod.; Fry, R. *Henri Matisse.* Paris, 1930, pl. 20; Jedlicka, G. *Henri Matisse.* Paris, 1930, pl. 20; Romm, A. *Matisse.* New York, 1947, p. 120; Cincinnati Art Museum, *The Lehman Collection, New York,* exhibition catalogue. Cincinnati, 1959, no. 176, p. 23; Acquavella Galleries, *Henri Matisse,* exhibition catalogue. New York, 1973, no. 31; Szabo, G. *The Robert Lehman Collection, A Guide.* The Metropolitan Museum of Art, New York, 1975, p. 95, no. 116. Pignatti, T. *Master Drawings from Cave Art to Picasso.* New York, 1981, p. 351.

THIS SMALL canvas, painted in Nice in 1923, is a simple composition of large surfaces covered with bold patterns surrounding the woman in Spanish costume. As the subtitle indicates, form and pattern are secondary, while the bright pulsating colors and their harmony dominate the painting in an overwhelming manner. As a recent study aptly summarized: "color now being employed across its whole, more-than-Impressionist range, became owned by Matisse in the years after 1916, as it was never owned by any other artist." The working study for this painting, in charcoal (as large as the canvas), is in the Centre Georges Pompidou, Musée National de l'Art Moderne, Paris.

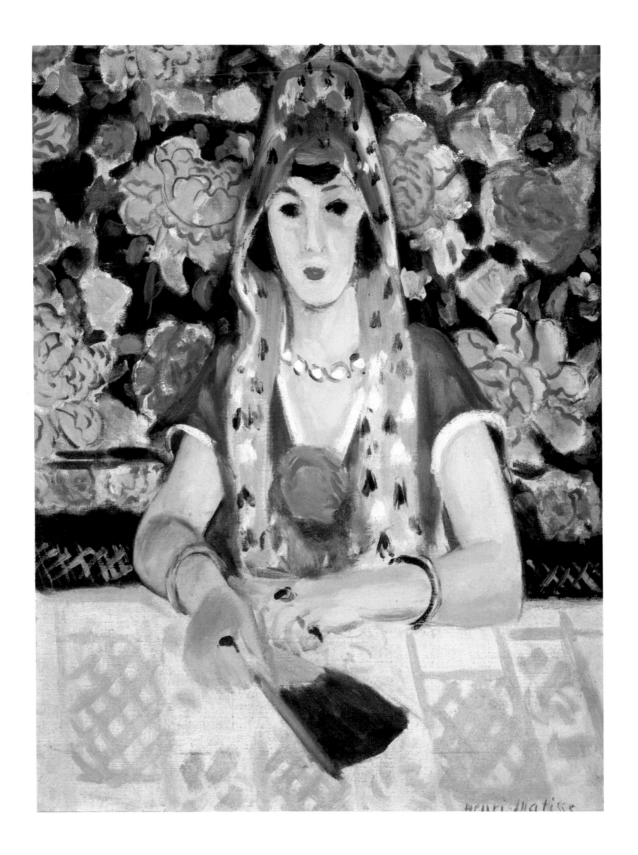

CLAUDE MONET
(1840-1926)

Landscape near Zaandam

Oil on canvas, H. 48 cm. x W. 73 cm. Signed and dated in lower left corner: *Claude Monet 72.*

Prov.: Collection of Bernheim-Jeune, Paris (1910); Collection of Paul Mendelsohn, Berlin.

Bibl.: Wildenstein, D. *Claude Monet. Biographie et catalogue raisonné.* Lausanne-Paris, 1974. Vol. 1, no. 186; Szabo, G. *The Robert Lehman Collection, A Guide.* The Metropolitan Museum of Art, New York, 1975, p. 98, no. 88; Martin-Mery, G. *Profil du Metropolitan Museum of Art de New York de Ramses à Picasso.* Bordeaux, 1981, no. 154, p. 126.

DESPITE THE date on the canvas, this luminous landscape was most likely painted in 1871. The artist was forced to leave Paris during the Franco-Prussian War of 1870, and, after a stay in London he went to Zaandam on the advice of Daubigny. The damp, diffused atmosphere and the canals lined with colorful houses were apparently very appealing to Monet. This light and airy painting conveys how this experience in Holland helped to give his palette a greater subtlety. This influence is quite noticeable on the first painting he executed in Argenteuil. Monet's Dutch landscapes were greatly admired by his fellow artists, and one of them was acquired by Daubigny himself.

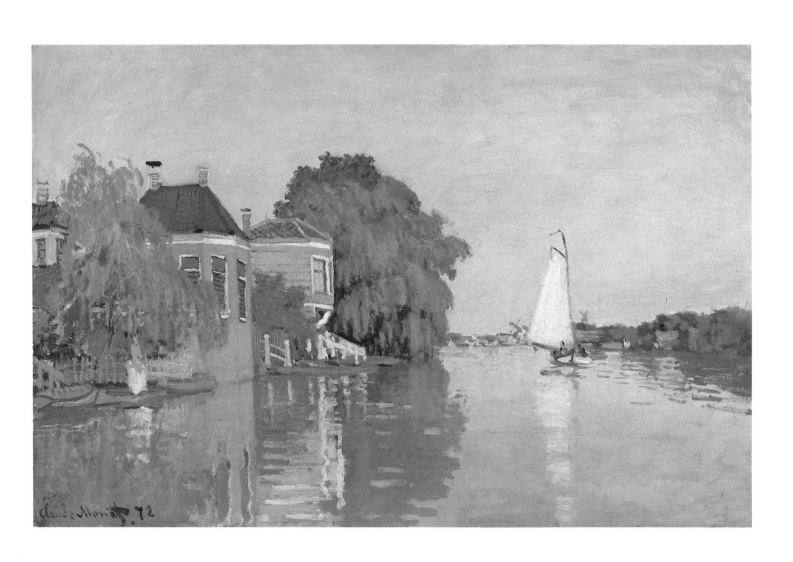

CAMILLE PISSARRO
(1830-1903)

Potato Gatherers

Oil on canvas, H. 46.1 cm. x W. 55.2 cm. Signed aand dated in lower right corner: *C. Pissarro 81.*

Prov.: Collection of Mrs. H. O. Havemayer, New York.

Bibl.: *The H. O. Havemayer Collection.* New York, 1931, p. 425; Pissarro, L. and Venturi, L. *Camille Pissarro, Son Art - Son Oeuvre.* Paris, 1939, Vol. I, p. 153, no. 516. Vol. II, pl. 106, no. 516; Szabo, G. *The Robert Lehman Collection, A Guide.* The Metropolitan Museum of Art, New York, 1975, p. 98, no. 90.

PISSARRO SETTLED in Pontoise in 1871 after his return from London and remained there for the rest of his life. He painted incessantly and provided constant advice and a gathering place for his friends and fellow artists; he is often called the "father of Impressionism". He painted this canvas in the fall of 1881, a year that was beset by financial and artistic difficulties for the group. Monet and Renoir were searching for new motifs and for further reaches in expressing color values.

Pissarro, however, remained imperturbable and retained the basic elements of his earlier achievements.

For his compositions, as on this canvas, he usually uses a tripartite structure: foreground, center stage and far-reaching background. However, here the emphasis is on the three potato gatherers. The working man and women dominate the composition, expressing the artist's new interest in the human figure. Pissarro's palette also had changed; it had become more refined and subtle. The landscape is a harmonious mixture of greens and yellows arranged in rhythmic layers as they represent the potato field, the trees, and the sunlit patches of the gentle hill behind them.

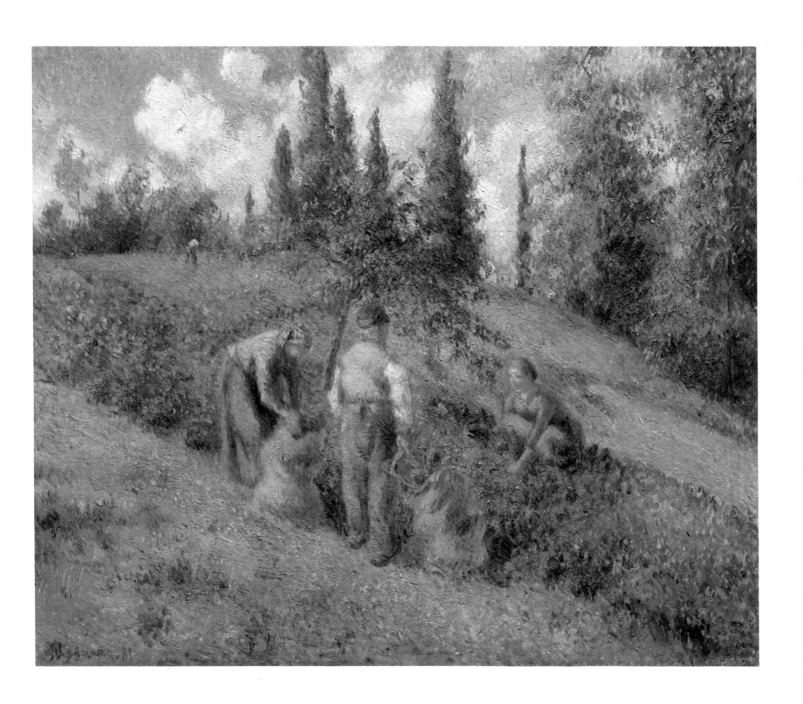

PIERRE-AUGUSTE RENOIR
(1841-1919)

Young Girl Bathing

Oil on canvas, H. 81.5 cm. x W. 65 cm. Signed and dated in lower left corner: *Renoir 92.*

Prov.: Collection of Claude Monet, Giverny; Collection of Mary Harriman, New York; Collection of George Gard Sylva, Los Angeles, California.

Bibl.: Reginier, H. de. *Renoir, peintre du nu.* Paris, 1923, p. 87; Valentiner, W. R. *The Mr. and Mrs. George Gard de Sylva Collection.* The Los Angeles County Museum, 1950, no. 50, pp. 40-41; Musée de l'Orangerie, *Exposition de la Collection Lehman de New York,* exhibition catalogue. Paris, 1957, no. 75, p. 57; The Cincinnati Art Museum, *The Lehman Collection, New York,* exhibition catalogue. Cincinnati, 1959, no. 156; Cogniat, R. *Renoir Nudes.* New York, 1959, pl. 11; Rewald, J. *The History of Impressionism.* New York, 1973, p. 581; Szabo, G. *The Robert Lehman Collection, A Guide.* The Metropolitan Museum of Art, New York, 1975, p. 92, no. 92; Oakley, L. *Pierre-Auguste Renoir.* The Metropolitan Museum of Art, New York, 1980, fig. 19; Royal Academy of Arts. *Post-Impressionism, Cross-Currents in European Painting,* exhibition catalogue. London, 1979-1980, no. 175, pp. 122-123.

AROUND 1892 Renoir painted many similar nudes of young girls bathing and this painting probably best exemplifies the method he described to an American artist-writer in 1908: "I arrange my subject as I want it then I go ahead and paint it like a child. I want a red to be sonorous, to sound like a bell; if it doesn't turn out that way, I put more reds or other colors till I get it. I am no cleverer than that. I have no rules and no methods; anyone can look at my materials or watch how I paint — he will see that I have no secrets. I look at a nude; there are myriads of tiny tints. I must find the ones that will make the flesh on my canvas live and quiver."

The complete mastery of color in this painting was recognized by the fellow Impressionist Claude Monet, who had it in his collection at Giverny. It is said that around 1920 he commented to a visitor on the painting, which hung over his bed: "The nude is beautiful . ."

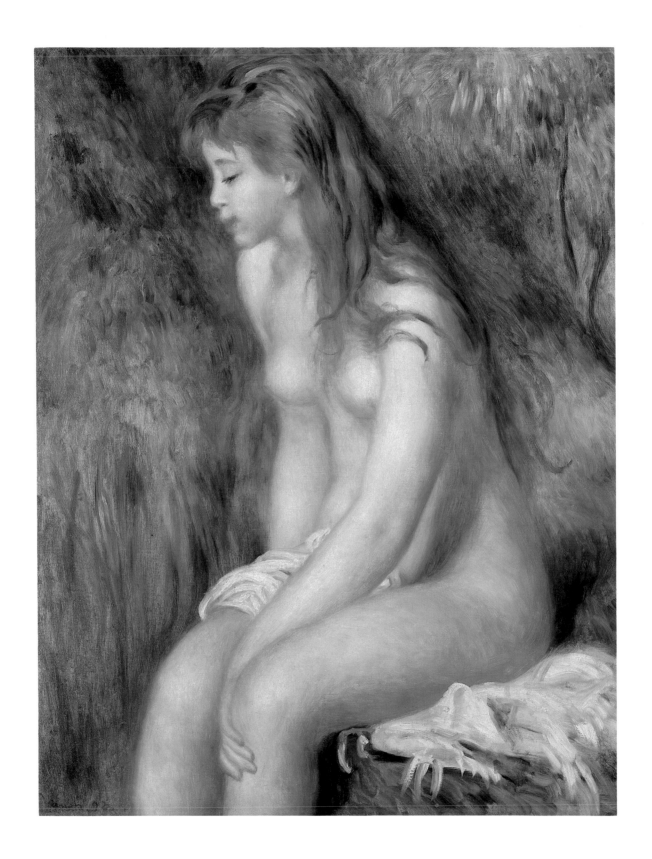

PIERRE-AUGUSTE RENOIR
(1841-1919)

Two Young Girls at the Piano

Oil on canvas, H. 112 cm. x W. 86 cm. Signed and dated in lower left corner: *Renoir 92.*

Prov.: Collection Durand-Ruel, Paris (acquired from Renoir on April 2, 1892); Collection of Paul Cassirer, Berlin; Collection of Mme. Furstenberg, Paris.

Bibl.: Pica, D. *Gl' Impressionisti Francesi.* Bergamo, 1908, p. 84; Vollard, A. *Renoir.* Berlin, 1924, p. 150; Meier-Graefe, D. *P. A. Renoir.* Leipzig, 1929, p. 252; Zahar, M. *Renoir.* Paris, 1948, pl. 162; Musée de L'Orangerie, *Exposition de la Collection Lehman de New York,* exhibition catalogue. Paris, 1957, no. 74, pp. 56-57; Cincinnati Art Museum. *The Lehman Collection, New York,* exhibition catalogue. Cincinnati, 1959, no. 154; Hayes, C. and Guerard, I. *Renoir.* Paris, 1963, pl. 23; Szabo, G. *The Robert Lehman Collection, A Guide.* The Metropolitan Museum of Art, New York, 1975, no. 93, p. 92; Isetan Museum of Art. *Renoir,* exhibition catalogue. Tokyo, 1979, no. 44; Oakley, L. *Pierre-Auguste Renoir.* The Metropolitan Museum of Art, New York, 1980, fig. 20.

IN THE years around 1892 the achievements of the Impressionists began to be recognized. About this time Renoir wrote to a friend, "The public seems to be getting accustomed to my art, why at this particular time?" This charming painting is partly the answer. The two figures in the comfortable and colorful interior are in the best tradition of French genre painting. The clarity of their presentation and the coordination of their movements are worthy of Chardin or Watteau. There is a formal solidity to the figures and a total harmony of the vibrant pinks, blues and pearly whites. The captivating animation of the faces, the soft movements of the arms and hands, as if echoing the music played, exude a special atmosphere and lend an extraordinary charm to the painting.

The identity of the two girls has not been established with certainty. They are most likely the Lerolle sisters, daughters of Henry Lerolle, a painter friend of Renoir's. In another version of this painting in the Louvre, the girls have been identified as the "daughters of Catulle Mendes." The composition must have been very pleasing not only to the sitters and to the public but to Renoir himself. He painted five more versions of it on canvas, one of which is in the Joslyn Art Museum in Omaha, Nebraska. In addition, the Metropolitan Museum now owns a small pastel version given by Mrs. Cynthia Foy Rupp.

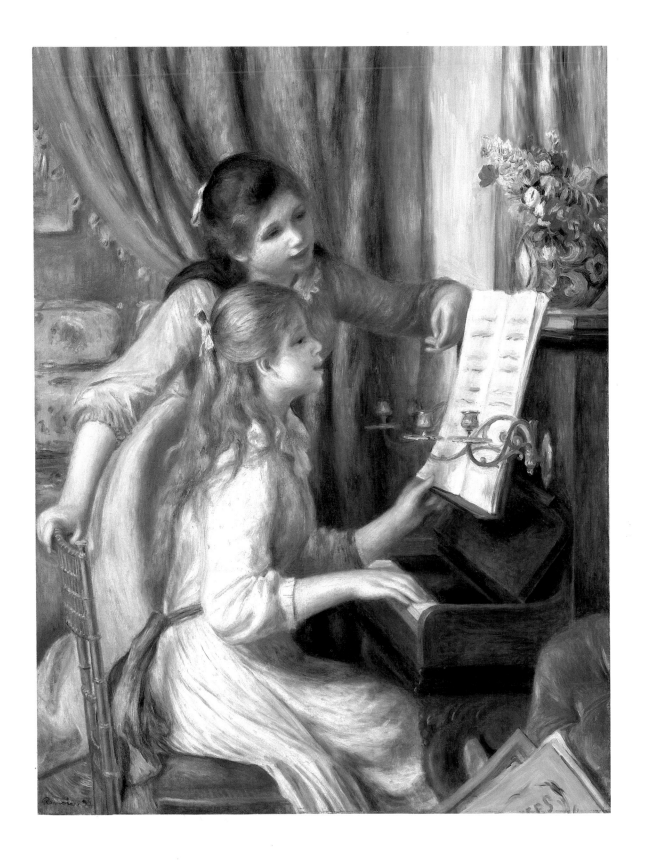

PIERRE-AUGUSTE RENOIR

(1841-1919)

Figures on the Beach

Oil on canvas, H. 52.7 cm. x W. 64.2 cm.

Prov.: Collection of Ambroise Vollard, Paris.

Bibl.: Vollard, A. *La vie et l'oeuvre de Pierre-Auguste Renoir.* Paris, 1919, p. 62; Cincinnati Art Museum, *The Lehman Collection, New York,* exhibition catalogue. Cincinnati, 1959, no. 150; Szabo, G. *The Robert Lehman Collection, A Guide.* The Metropolitan Museum of Art, New York, 1975, p. 99, no. 94; Oakley, L. *Pierre-Auguste Renoir.* Metropolitan Museum of Art, New York, 1980; Martin-Mery, G. *Profil du Metropolitan Museum of Art de New York de Ramses à Picasso.* Bordeaux, 1980, no. 155, p. 127.

THIS CANVAS, with the broad expanse of the sea and sky in the background and the pleasant looking figures in the front, is unusual among the landscapes painted by Renoir in the 1890's. The organization of these elements into a harmonious composition is also noteworthy. There is a perfect balance between the horizontal fields of the sea, the sky, and the beach. The pivotal position of the standing figure divides the pictorial field vertically into two equal halves, both of which are filled with small secondary components such as the little boy at the edge of the water or the sailboats in the upper right corner. The painting belonged to Renoir's famous dealer, Ambroise Vollard, who also published it first in his oeuvre catalogue of the artist's work in 1919. *Figures on the Beach* is one of the many landscapes in the Lehman Collection that can be characterized as always restrained and harmonious.

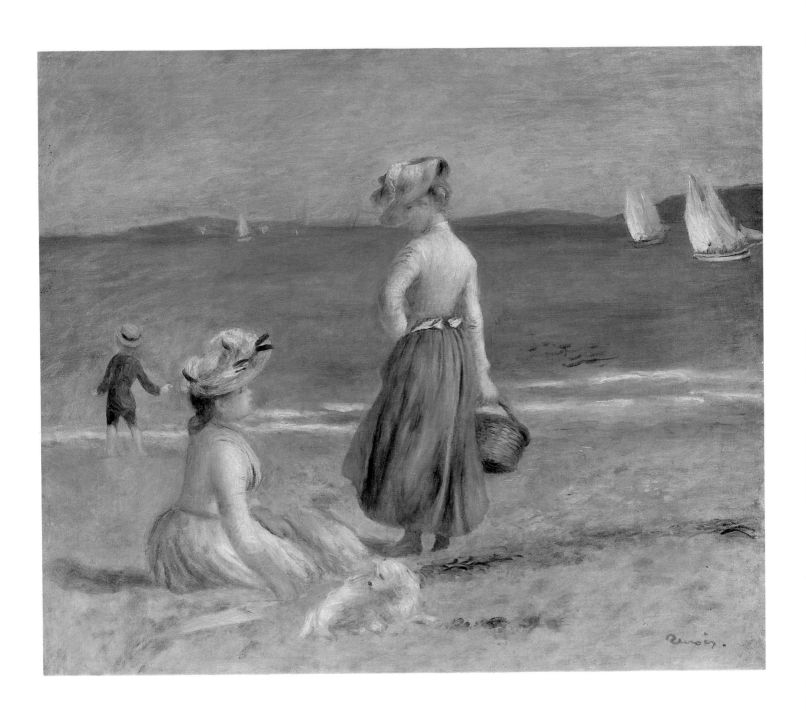

GEORGES ROUAULT

(1871-1958)

"Paysage Légendaire"

Oil on, canvas, H. 50.8 cm. x W. 50 cm. Signed and dated in lower left corner: *Rouault 36.*

Prov.: Collection Bing, Paris; Galerie Petrides, Paris.

Bibl.: Unpublished.

ROUAULT, AT the age of fourteen, became apprenticed to a stained glass window maker. The technique of the craft, using the strong outlines of the lead strips to define and divide larger fields of pure color, exerted a strong influence that lasted throughout his life and oeuvre. It is very much in evidence in this rather late canvas, where the landscape and the figures in it are marked and outlined in black. However, there is a luminosity of color and softening of contours here that is a marked contrast to his earlier, sometimes almost brutal compositions. This relaxation is in harmony with the mysterious feeling of some legend or perhaps some still unidentified Biblical story that emanates from the painting.

One has the feeling that the canvas illustrates Rouault's words: "I do not feel as if I belong to this modern life . . . my real life is back in the age of the cathedrals."

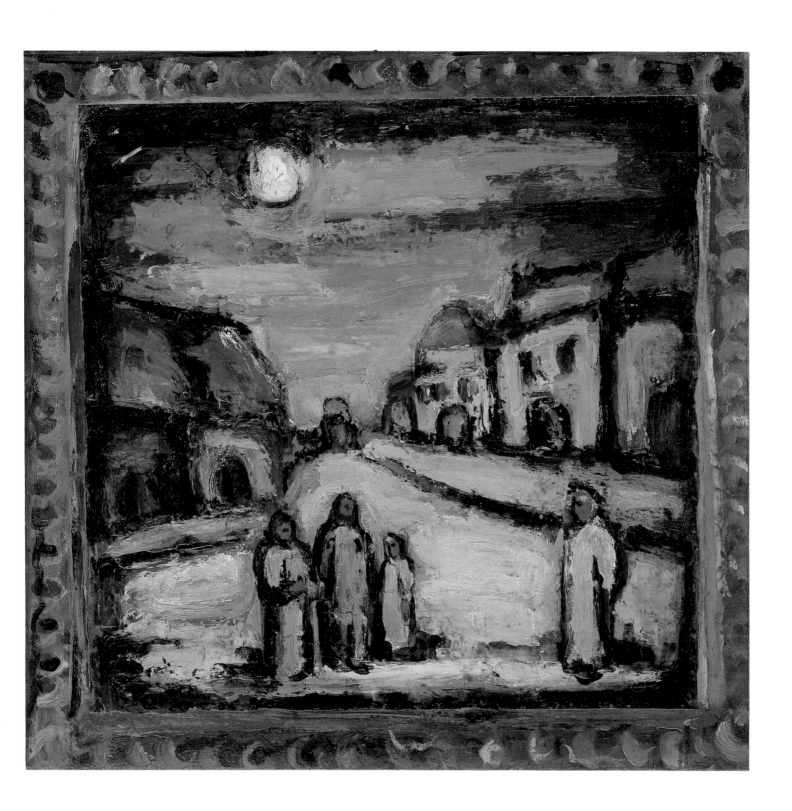

PAUL SIGNAC

(1863-1935)

View of Collioure

Oil on canvas, H. 62.9 cm. x W. 80 cm. Signed and dated in lower left corner: *P. Signac. 87.* Inscribed by the artist in lower right corner: *Op. 165.*

Prov.: Collection Teissier, Paris, (1897); Collection of G. Levy, Paris (1928).

Bibl.: *Cinquième exposition des XX.* Bruxelles, 1888, no. 10; *Quatrième exposition des Artistes Indépendants.* Paris, 1888, no. 630; Galerie Bernheim-Jeune. *Paul Signac.* Paris, 1930, no. 7; Rewald, J. *Post-Impressionism from Van Gogh to Gauguin.* New York, 1956, p. 244; Cincinnati Art Museum, *The Lehman Collection, New York,* exhibition catalogue. Cincinnati, 1959, no. 165; Musée de Louvre. *Signac,* exhibition catalogue. Paris, 1963-1964, no. 22 (with full bibliography); Cachin, F. *Signac.* New York Graphic Society, Greenwich, Conn., 1971, p. 38; Szabo, G. *The Robert Lehman Collection, A Guide.* The Metropolitan Museum of Art, New York, 1975, pp. 100-101, no. 104; Szabo, G. *Paul Signac (1863-1935) Paintings, watercolors, drawings and prints.* The Metropolitan Museum of Art, New York, 1977, no. 1, p. 11.

THIS PAINTING is one of twelve that Signac sent to Brussels in 1888 at the invitation of Octave Maus to be shown in the exhibition of the Belgian group *Les XX.* Ever since, it has been considered one of the artist's outstanding works. The very appealing canvas, painted in August and September 1887, is an excellent example of Signac's "pointillist" or "divisionist" style. It is executed entirely in small dots of primary colors; their connection and combination decide the intensity of the color impression. The size of the dot usually indicates the distance; they are larger when supposed to be closer to the onlooker, smaller when far away. Collioure is in the southernmost part of France, and its rocky bay with its stark buildings had a special appeal for Signac. He once wrote: "Blue sky, blue sea, and all the rest burned orange; thus a forced harmony. In that respect the *'Midi'* is splendid". The mention of harmony in this quote as well as Signac's use of "opus" numbers, borrowed from musical terminology, hints at Signac's friendship with the Symbolist poets who often employed musical symbolism. The Belgian poet Emile Verhaeren was the first who acclaimed in this painting "Signac's uncontested qualities as a humanist painter." Félix Fénéon in 1888 wrote admiringly about the "exquisitely golden line of the whole series" that Signac sent to Brussels, but singled out this canvas for its special qualities. He praised "its perspective effects that thrust the sea into the beach at an acute angle, houses harsh as fortresses, absence of greenery, ultimate calm, a blondness infinitely gentle . . . More superbly than ever M. Signac displays his virtues of observation and harmony."

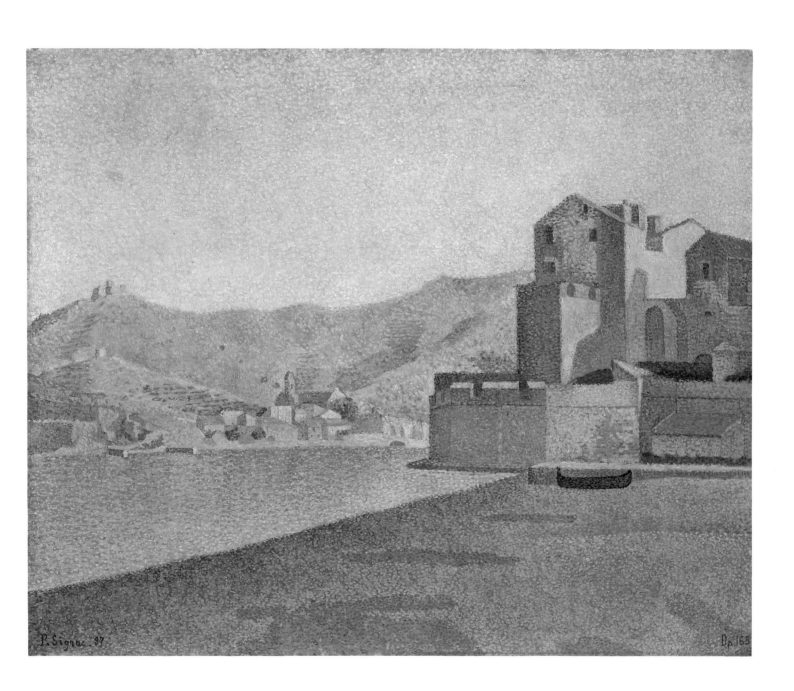

ALFRED SISLEY

(1839-1999)

Alley of Chestnut Trees

Oil on canvas, H. 50.2 cm. x W. 61 cm. Signed and dated in lower right corner: *Sisley '78*

Prov.: Collection of Tadamasha Hayashi, Paris - Tokyo; Collection of Mrs. H. O. Havemeyer, New York.

Bibl.: *The H.O. Havemeyer Collection.* New York, 1931, p. 427; Daulte, F. *Alfred Sisley: Catalogue raisonné de l'oeuvre peint.* Lausanne, 1959, pl. 268; The Cincinnati Art Museum, *The Lehman Collection, New York,* exhibition catalogue. Cincinnati, 1959, no. 149, p. 22; Wildenstein and Co. *Sisley, An Exhibition,* exhibition catalogue. New York, 1966, no. 37; Szabo, G. *The Robert Lehman Collection, A Guide.* The Metropolitan Museum of Art, 1975, p. 98, no. 89.

AS THIS peaceful landscape is dated 1878, one would expect it to reflect the personal problems that beset the artist in that year. Sisley, born of English parents in Paris, was forced to change his lodgings several times that year because of financial difficulties. Finally he and his family settled in Sèvres and were no sooner installed than he began to paint. The subject was of no importance to him as long as it was landscape. With an unparalleled love of nature and with luminous colors he created "the most restrained and harmonious landscapes to the glory of the Ile-de-France." The charm and beauty that emanate from this canvas is reflected in its distinguished provenance. Its first owner was the Japanese dealer and collector, Hayashi Tadamasha. From 1878 he resided in Paris and sold *ukyo-e* prints to French collectors and artists such as Edmond de Goncourt and Monet, thus greatly contributing to the fashion of *japonisme* among the Impressionists. In 1900 Hayashi was chief commissioner of the Japanese Government to the *Exposition Universelle.* From the sale of his French Impressionist paintings in New York in 1913 several pioneer American collectors acquired canvases, among them Mrs. Havemeyer.

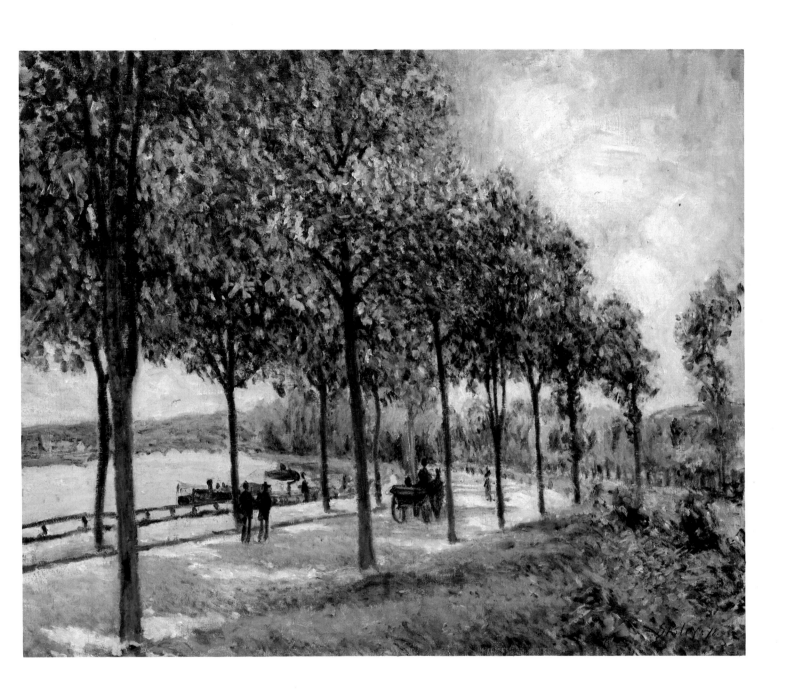

PAUL DÉSIRÉ TROUILLEBERT
(1831-1900)

Early June Landscape

Oil on canvas, H. 54.6 cm. x W. 66 cm. Signed in lower left corner: *Trouillebert.*

Prov.: Unknown.

Bibl.: Unpublished.

TROUILLEBERT BECAME famous when one of his canvases was sold by Alexandre Dumas *fils*, as a celebrated work of Corot. This painting also demonstrates the similiarities between the works of Corot and his late follower which for a long time created confusion and misunderstandings.

The pleasant composition and the quietude of this painting seem to indicate that it was painted around 1899.

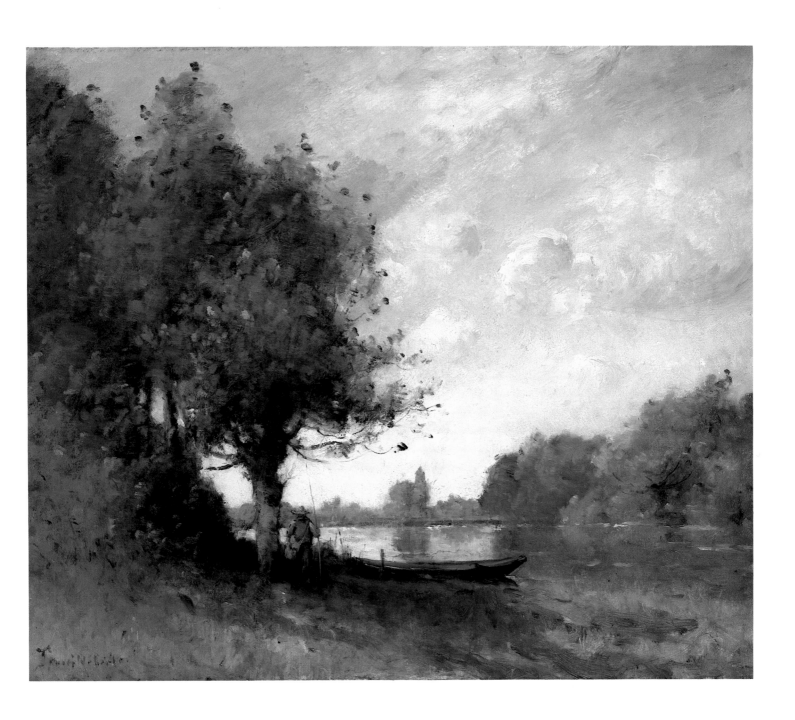

MAURICE UTRILLO V.
(1883-1955)

40, rue Ravignan

Oil, plaster of Paris and sand on board, H. 54 cm. x W. 73.7 cm. Signed in lower right corner: *Maurice Utrillo V.*

Prov.: Collection of Louis Libaude, Paris; Collection of John Barber, Philadelphia, Pennsylvania.

Bibl.: Szabo, G. *The Robert Lehman Collection, A Guide.* The Metropolitan Museum of Art, New York, 1975, p. 102, no. 118.

MAURICE UTRILLO, Suzanne Valadon's son (hence the "V." after his signature) was the painter *par excellence* of the Montmartre of Paris. With untiring eye and diligence, he painted the stark colors of the small houses, cafés and other haunts of artists lining the winding, steep streets of this famous part of Paris. This painting represents number 40 of rue Ravignan, one of the oldest streets of Montmartre. Even today, it is cobblestoned and lined with two- and three-storey buildings as it was around 1913 when Utrillo painted this canvas. The dominance of white and grey indicates that it is from his so-called "white period". Eyewitnesses say that around 1910, Utrillo became fascinated with the white buildings of Montmartre, perhaps as a reaction to the colors of Impressionist influences. In order to simulate the rough texture of their walls, he mixed some plaster of Paris and sand into his paint and created a whole range of silky whites and coarser greys.

On the verso of the board there is a black chalk drawing that occupies almost the whole right half. It represents the upper torso of a corpulent, nude woman leaning forward. The spontaneous and still fresh drawing is not by Utrillo, but by his mother Suzanne Valadon. It is most likely the first study — perhaps the only known study — for her famous painting *Ni blanc — ni noir* or *After the Bath*, as it is sometimes called, painted in 1909 (Centre Pompidou, Paris).

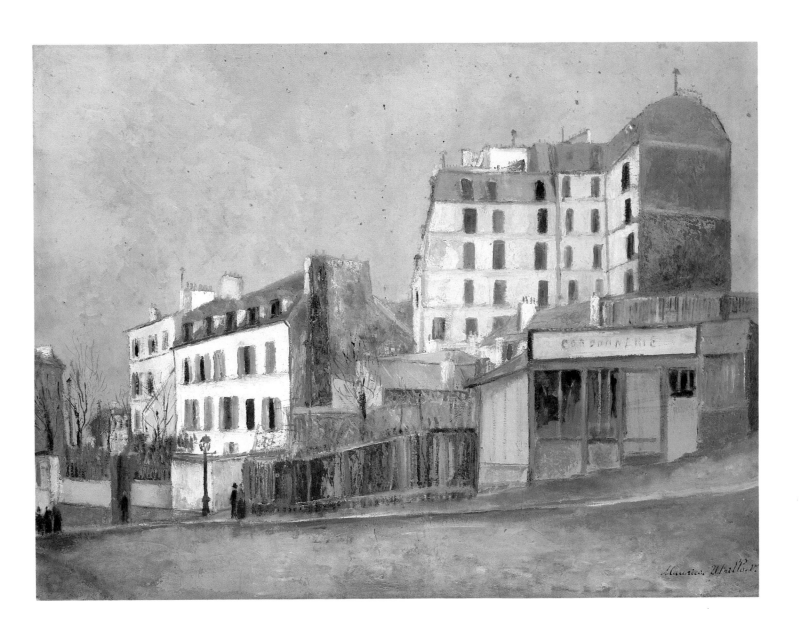

SUZANNE VALADON

(1867-1938)

Reclining Nude

Oil on canvas, H. 60 cm. x W. 80.5 cm. Signed and dated in upper right corner: *Suzanne Valadon 1928.*

Prov.: Unknown.

Bibl.: Mermillon, M. *Suzanne Valadon (1867-1938).* Paris, 1950, pl. 43; Haus der Kunst. *Maurice Utrillo V. - Suzanne Valadon,* exhibition catalogue. Munich, 1960, p. 30, no. 184, pl. 91; Szabo, G. *The Robert Lehman Collection, A Guide.* The Metropolitan Museum of Art, New York, 1975, p. 102, no. 119.

THE STRIKING *Reclining Nude* is a major work by an artist who still has not received the recognition she deserves. Her life was almost entirely spent in and around painting. From the early 1880's on, Marie-Clémentine (she later adopted the name Suzanne) was a favorite model of Puvis de Chavannes, Renoir, Degas, and Toulouse-Lautrec. The latter two discovered her talent for drawing and also encouraged her to paint and engrave as well. She first exhibited at the Salon in 1895.

This canvas, a mature work dated 1928, reflects Valadon's predilection for line: the contours are firmly and beautifully drawn without unnecessary detail. The nude is sensitively positioned into the curve of the sofa; the delicate greens of the upholstery cast interesting light on the skin of the body and face. In spite of the delicate balance of color and form between the large sculpture-like mass of the body and the minutiae of the fabric, there is an almost brutal realism in the nude in the painting, a reflection seemingly of her long experiences as a woman. This canvas could serve as an illustration to Valadon's motto: "To paint as one can as one knows best."

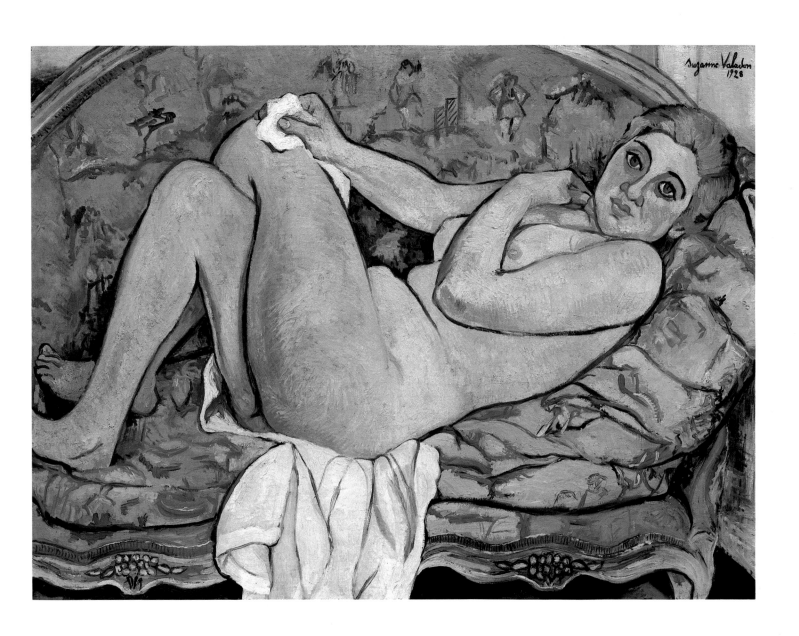

LOUIS VALTAT
(1869-1952)

Woman on the Seashore

Oil on canvas, H. 81 cm. x W. 100.3 cm. Signed in lower right corner: *L. Valtat.*

Prov.: Unknown. Purchased from Lock Galleries, New York, 1961.

Bibl.: Szabo, G. *The Robert Lehman Collection, A Guide.* The Metropolitan Museum of Art, New York, 1975, p. 101, no. 112.

ALTHOUGH UNDATED, it is known that this canvas was painted around 1902. The scene is the famous red rocks *(roucas rou)* of the seashore near Valtat's house in Antheor on the French Riviera. The ragged diagonal of the rocks cuts through the whole composition; the reds, purples and yellows in the turbulent lower half are perfectly set off by the calm bluish-white and lavender of the sea and sky. The seated woman is hardly distinguishable from her surroundings: her undulating dress could be a piece of rock, her straw hat blends in with the yellow sand.

The bold colors, the forcefully undulating forms, and the powerful division of the pictorial field all forecast the artist's future direction: he was one of the Fauves in the autumn Salon of 1905. For a long time, Valtat was overshadowed by his contemporaries Matisse, Bonnard, Vuillard, and Rouault. These painters were divided into two distinct groups, and their search for artistic expression differed widely. As Raymond Cogniat noted: ". . . Vuillard and Bonnard were directly associated with Impressionism . . . they are full of gentle peaceful intimity . . . on the other hand, Matisse and Rouault adopted an attitude of violent opposition, they rejected subtle modulations in favor of vivid contrasts . . . Valtat's style lays in between these two extremes . . . it is an admirable example of integrity suffused with the joy of life."

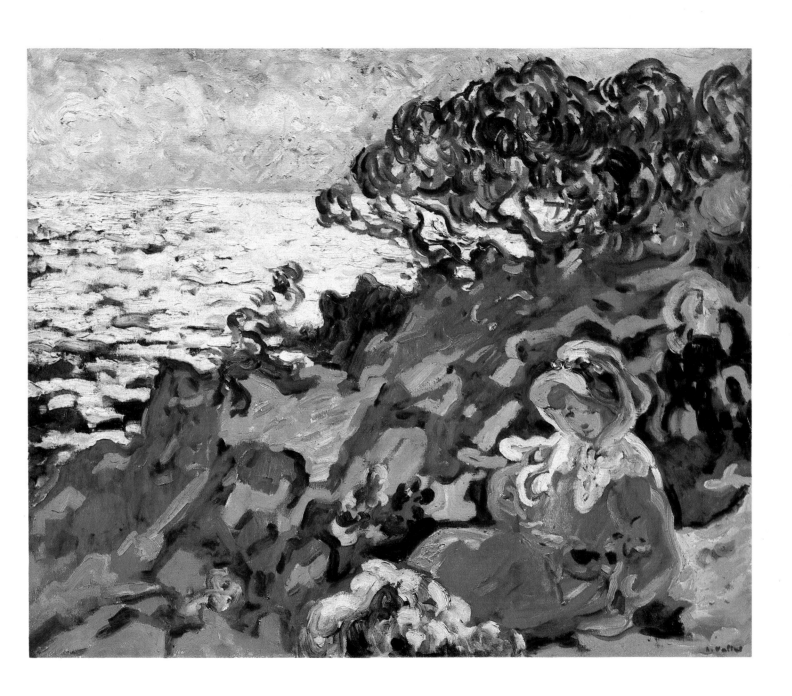

JACQUES VILLON
(1875-1963)

Self-Portrait

Oil on canvas, H. 46 cm. x W. 38 cm. Signed in lower right corner: *Jacques Villon.* Also inscribed by the artist on the verso of the canvas: *Jacques Villon 23.*

Prov.: Galerie Louis Carré, Paris.

Bibl.: Unpublished

DURING HIS long career Villon explored and recorded his own image many times in paintings, drawings and etchings. However, there are few from the 1920s, when this one was painted. This restrained self-image is also important for another reason. The year 1922 marked the end of Villon's first abstract period. For several years in the mid-twenties he returned to the example of the old masters, making color engravings after famous compositions of Manet, Rousseau, Renoir and Van Gogh. All these are reflected in this canvas. The colors are muted and used to represent the shapes of the face. But they also convey a feeling of bleakness and emptiness, as if the artist wanted to record dissatisfaction with himself. By the 1930s, he apparently regained self-confidence, turning to a palette of more blues, greens and violets.

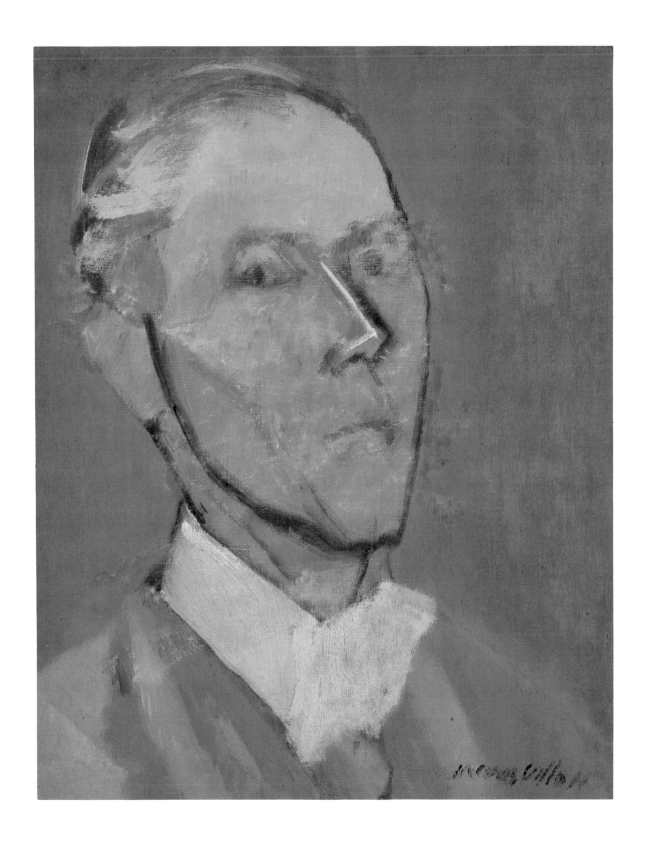

MAURICE VLAMINCK

(1876-1958)

Sailboats on the Seine

Oil on canvas, H. 54.6 cm. x W. 73.7 cm. Signed in lower left corner: *Vlaminck*

Prov.: Unknown. Acquired in 1958 from Lock Galleries, New York.

Bibl.: Sauvage, M. *Vlaminck, Sa vie et son message.* Geneva, 1956, p. 72; Sindona, E. *Gallerie della pittura europea.* Milan, 1961, p. 247; Crespelle, J.-P. *Les Fauves.* Geneva, 1962, pl. 61; Perls Galleries. *Vlaminck - His Fauve Period,* exhibition catalogue. New York, 1968, no. 21; Szabo, G. *The Robert Lehman Collection, A Guide.* The Metropolitan Museum of Art, New York, 1975, p. 101, no. 110; Martin-Mery, G. *Profil du Metropolitan Museum of Art de New York de Ramses à Picasso.* Bordeaux, 1981, no. 156, p. 128.

THIS CANVAS and several others in the Lehman Collection reflect Robert Lehman's special appreciation of the artist's famous Fauve period between 1903-1907. At this time Vlaminck was living and painting in the small community of Chatou on the banks of the Seine, not far from Paris. Like his companion Derain, he was fascinated by the river landscape, its surroundings, and the constantly changing colors. He painted this canvas in 1906 not far from Chatou, near Rueil, and in it the full force of his palette explodes like fireworks. The wonderful composition, its bold strokes of color, and the creative energy that emanate from it defy any description. But to understand it better, the artist's comments on his method may be quoted: "I heightened all tones . . . I transposed into an orchestration of pure colors all the feelings of which I was conscious. I was a barbarian, tender and full of violence, I translated my instinct, without any method, not merely an artistic truth but above all a human one. I crushed and botched the ultramarines and vermilions though they were expensive."

Vlaminck's creations burst, his "scorching" colors were in direct defiance of all the traditions upheld by the academies and even by many of the Impressionist school and their followers.

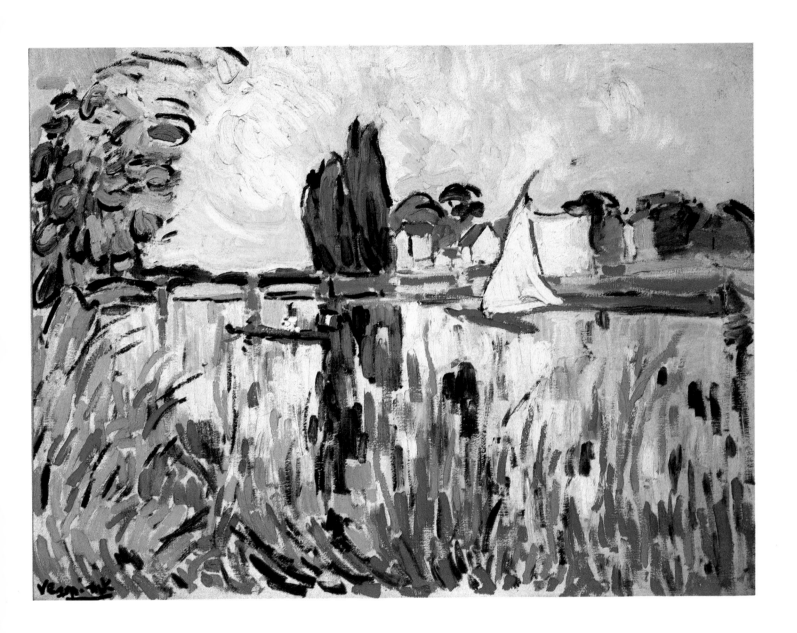

EDOUARD VUILLARD
(1868-1940)

The "Foyer"

Oil on canvas, H. 45 cm. x W. 37.5 cm. Signed in lower right corner: *E. Vuillard.*

Prov.: Unknown. Acquired in the late 1940's.

Bibl.: The Cincinnati Art Museum. *The Lehman Collection, New York,* exhibition catalogue. Cincinnati, 1959, no. 171, p. 23.

MME. VUILLARD, the artist's mother, exerted a great influence on her son and appears in many of his paintings. Her solitary figure is ever present, in many moods and colors and always surrounded by the vibrant backgrounds of fabrics and wallpapers. In this painting from the mid 1890's, she is shown in an entrance foyer where the receding spaces and painted surfaces go from the plain and unadorned area on the right through the balustrade of the staircase to a patch of rich pattern in the upper left corner. A critic wrote of Vuillard in 1893: "His is an art . . . of attitudes, and folded arms, and pale hands. Vuillard has found a new and delicious way of expressing the poetry of a quiet hearth and the beauty of thought and action that underlies that poetry."

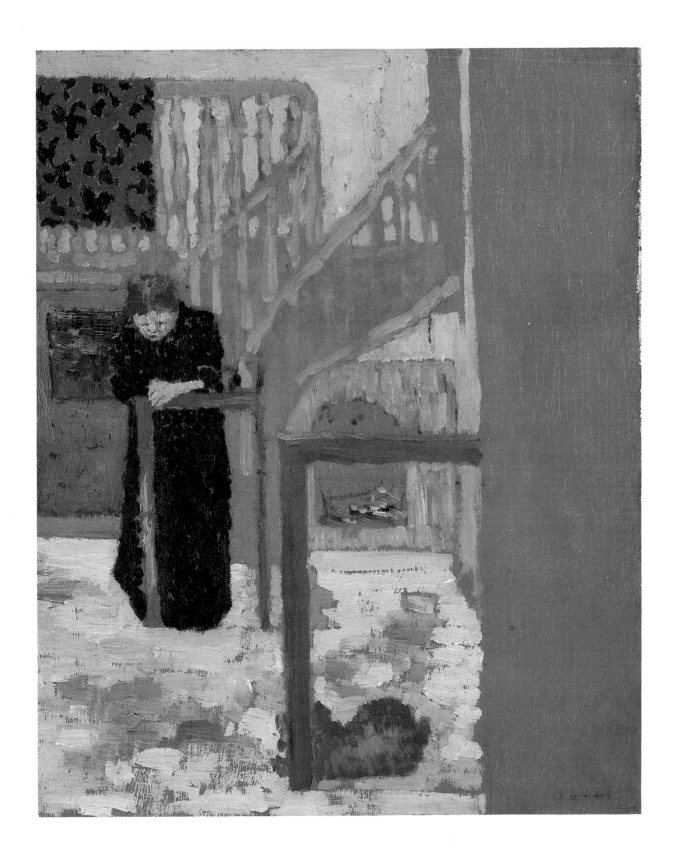

EDOUARD VUILLARD
(1868-1940)

Girl at the Piano

Oil on board, H. 26 cm. x W. 25 cm.

Prov.: Unknown. Purchased in the 1950's

Bibl.: Cincinnati Art Museum, *The Lehman Collection, New York,* exhibition catalogue. Cincinnati, 1959, no. 172; Szabo, G. *The Robert Lehman Collection, A Guide.* The Metropolitan Museum of Art, New York, 1975, p. 95, no. 102.

VUILLARD AND Bonnard were the leading members of the Nabis. Their love of color is quite evident in this small painting too. Although not dated, it is generally considered to be from around 1896. There is a delicate vibrancy in the lively pattern of the wall-paper and a feeling of deep intimacy in the profiled figure. The objects and shadows are undifferentiated and their dark field provides a neutral contrast to the wall that recalls the elaborately embellished *mille-fleur* tapestries of Medieval France.

The young woman at the piano is probably Misia Godebska, wife of Thadée Natanson, publisher of the magazine *Revue Blanche, femme fatale* and model for many famous artists of the turn of the century. Vuillard himself made lithographs for Natanson and was a close friend of Misia. He painted her and her husband many times. Closest to this painting is a small panel with Misia playing the piano in the same room (now in the Museum of Bern). During the late 1890's, Vuillard painted a large number of small panels all dominated by vivid patterns. It has often been said that the artist's interest in them was in part due to his beloved mother who came from a family of textile designers and who, after her husband's death, operated a dressmaker's shop where there was a great abundance of fabrics. On the other hand, the proliferation of rich patterns in Vuillard's art is sometimes attributed to his love of Japanese prints, which were greatly favored by the Nabis and exerted a considerable influence on their art. Be that as it may, Paul Signac's characterization of Vuillard's paintings is still valid: "They are the work of a fine painter, these many colored panels, predominantly dark in key, but always with an explosion of bright color that somewhere re-establishes the harmony of the whole picture."

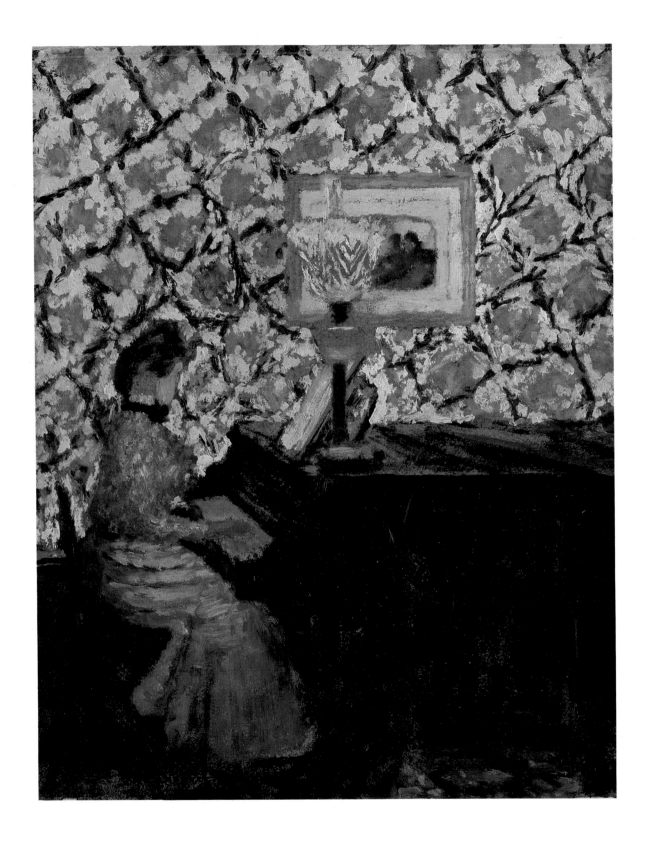